You can help reverse global warming.

Just scan the QR codes.

Solar Sister:
Help a women entrepreneur bring solar power to her community in rural Africa.

Australian Museum:
Learn. Engage. Join a group. Take action.

The Climate Mobilization:
Become a climate warrior!

Copenhagen International School:
Copenhagen International School has already supported two 1,000 tree forests and is now raising funds for its third 1,000 tree forest in Inner Mongolia.

Green Monday:
Help yourself and the planet by shifting to a plant-based diet.

Women's Earth Alliance:
Take action with a global network of women environmental and climate leaders.

COOL

Published in the United States by powerHouse Books, a division of powerHouse Cultural Entertainment, Inc. 32 Adams Street, Brooklyn, NY 11201

www.powerHouseBooks.com

First edition, 2022

Library of Congress Control Number: 2021943648

ISBN 978-1-57687-954-2

Book design by Francesca Richer
Artistic renditions by Robert Avellan

Printed by GPS Group via ODDI Sales

FSC
www.fsc.org

MIX
Paper | Supporting
responsible forestry
FSC® C118234

COOL: Women Leaders Reversing Global Warming was printed using linseed oil-based inks: Novavit® BA 9769 BIO is a colour intense, duct-fresh, very fast setting process ink series, based on renewable raw materials and formulated with the newest binder technology, on paper cultivated and harvested according to the timber certificate of the manufacturer of this book issued by the Forest Stewardship Council. For more information on the FSC and what it does internationally, go to fsc.org.

10 9 8 7 6 5 4 3 2 1

Printed and bound in Slovenia

COOL

WOMEN LEADERS REVERSING GLOBAL WARMING

Paola Gianturco

Avery Sangster

pH **powerHouse Books**

BROOKLYN, NY

CONTENTS

"WOMEN ARE ESPECIALLY EFFECTIVE LEADERS WHEN IT COMES TO COMBATING GLOBAL WARMING."

INTRODUCTION
Paola Gianturco

As you know, carbon dioxide emissions are the number one cause of global warming. As you're about to discover, women around the world are leading organizations that are reducing and, over time, reversing them.

Leaders like Meagan Fallone, CEO of India's Barefoot College International, whose organization has trained women in 96 countries to build and install solar panels.

Leaders like Natalie Isaacs, Founder of 1 Million Women in Australia, who has inspired women all over the world to reduce their families' carbon footprints.

Leaders like Dominique Browning, who founded Moms Clean Air Force, whose US-based organization educates parents to advocate for action against climate change in meetings with elected officials.

Leaders like Anna Bergström, Manager of ReTuna in Sweden, who put her museum experience to work to create a high-design shopping center offering merchandise that has been imaginatively restored and repurposed.

Women and girls all over the world are using intelligence, creativity, energy, and courage to help stop global warming. And they are making progress. *COOL: Women Leaders Reversing Global Warming* documents their inspiring work and invites you to join them.

My 12-year-old granddaughter and co-author, Avery Sangster and I interviewed and photographed more than two dozen women and girl leaders for this book, all of whom guide initiatives that aim to save our planet and our species.

We discovered a salient fact along the way: Women are especially effective leaders when it comes to combating global warming. In their book, *The Future We Choose*, Christiana Figueres and Tom Rivett-Carnac, architects of the 2015 Paris Agreement, reported, "Nations with greater female representation in positions of power have smaller climate footprints. Companies with women on their executive boards are more likely to invest in renewable energy and develop products that help solve the climate crisis. Women legislators vote for environmental protections almost twice as frequently as men, and women who lead investment firms are twice as likely to make investment decisions based on how companies treat their employees and the environment."

More support for women's effectiveness comes from FP Analytics (the independent research division of *Foreign Policy* magazine): Companies that increased the percentage of women on their boards between 2014 and 2018 were 60% more likely to reduce energy consumption and 39% more likely to reduce greenhouse gas emissions. They were also more likely to employ greener production processes and to invent environmentally sustainable alternatives.

With excitement and high hopes, Avery and I began this book.

*

Our first step was to create a "long list" of women leaders working to:

* Enhance Awareness (museums, demonstrators, even dancers)
* Invent Solutions (scholars, scientists)
* Reduce Emissions (companies and nonprofits)
* Set Policy (government officials)
* Demand Action (activists and advocates)

We set a strict standard when we were evaluating candidates for the "Reduce Emissions" category. The solution each woman leader was working on had to be named in the book *Drawdown, The Most Comprehensive Plan Ever Proposed to Reverse Global Warming,* which identifies, quantifies, and ranks 80 solutions that will, in the aggregate, reverse global warming by 2050. *Drawdown* was created by more than 200 scientists, scholars, policymakers, business leaders, and activists around the world.

Next, Avery and I balanced our "long list" geographically. *COOL* includes women leaders working courageously in the regions that contribute the most emissions (China, the United States, the European Union, and India). It includes women working in regions that have been hard-hit by climate change (Australia, Tanzania, the Arctic). It includes women working in cities such as Copenhagen, as well as in rural areas like coastal Sri Lanka.

Finally, because there is no single way to reverse global warming, we chose women leaders doing work as diverse as solar installations and bicycle superhighways. Their political positions range from "end capitalism" to "work within the current economic system." And since reversing global warming must involve everyone, the women leaders in this book represent a broad variety of cultures and ethnic groups.

Ultimately, Avery and I interviewed and photographed women and girl leaders based in the United States, Canada, United Kingdom, Sweden, Denmark, Tanzania, Australia, Sri Lanka, India, and Hong Kong. (And yes, we offset our airline miles by contributing to the EARTHDAY.org's Canopy Project.)

*

Perhaps you have not yet taken action on global warming because the threat seems too existential to contemplate, the impact that one person can have is not apparent, or the science seems too complicated to understand. As Natalie Isaacs of 1 Million Women says, "You don't need to know all the scientific facts before you act." But here is some key information.

Greenhouse gases cause global warming. Think about how a greenhouse traps heat inside the building. Similarly, greenhouse gases (77% carbon dioxide, 16% methane, plus

others) form an invisible bubble around the earth that traps the sun's heat. "The carbon dioxide molecule's unique shape intercepts and then absorbs heat," as Hope Jahren writes in her *Story of More.*

Most greenhouse gas emissions come from burning fossil fuels (coal, petroleum, natural gas) to produce electricity and heat (25%), or from agriculture and forestry (24%), industry (21%), or transportation (14%).

Global warming catalyzes climate change. As the earth's surface temperature warms, it plays havoc with the way climate traditionally functions. Already, we have seen droughts threaten human life in Africa and India—and feed wildfires that kill people in California and Australia. As Arctic ice melts, floods cause deaths in Florida, Bangladesh and Latin America. With each lethal climate event, it becomes more evident that if we want to save our species, we must reverse global warming.

Scientists (and some politicians) agree that if we start immediately and use available methods, by 2050 we can hold the planet's average temperature increase to 2 degrees Celsius (3.6 degrees Fahrenheit) above the average global temperature recorded in 1880 when weather stations were first ubiquitous enough to provide such a number. Better yet, we should hold the increase down to 1.5 degrees Celsius (2.7 degrees Fahrenheit).

If our earth's temperature increases more than 1.5 or 2 degrees Celsius, global warming will be difficult to slow, increasingly deadly, and ultimately irreversible. How long before that happens? Experts say we must have net zero emissions by 2050; to get there, we must halve global emissions by 2030. We must start now.

Responsibility for global warming rests with all of us. The biggest shares of global carbon dioxide emissions come from China (30%), the US (15%), the European Union (9%), India (7%), Russia (5%), and Japan (4%), but everyone everywhere must collaborate.

Elected officials must establish and fund programs and policies that limit greenhouse gas emissions.

Governments must allocate funds to retrain people currently doing emission-generating work, so they can perform new jobs. There will be plenty of opportunities.

Emission-producing economic sectors must develop less pernicious ways to conduct business.

And we must modify our lifestyles. Every story in this book ends with the women leaders' ideas about what you can do. Pick one or two ideas after you read each chapter, and join this important work. The QR codes will take you to information about how and why to act on the leaders' suggestions.

So how do we reverse global warming? Two steps: reduce the amount of greenhouse

> "Nations with greater female representation in positions of power have smaller climate footprints."

gases that enter the atmosphere—and remove greenhouse gases from the atmosphere. This book tells about strategies that do both.

<p style="text-align:center">*</p>

Since many of the women and girls Avery and I interviewed are leading initiatives that reflect *Drawdown's* 80 solutions, we quote from that book in some chapter sections subtitled "Why It Matters." It will help readers understand those sections to know that *Drawdown*:

* ranks its solutions based on the total amount of greenhouse gases each solution can avoid or remove from the atmosphere
* converts all greenhouse gas emissions to carbon dioxide equivalents
* projects each solution's result in terms of gigatons (a gigaton of carbon dioxide equals about 2 trillion pounds, or one billion metric tons).

<p style="text-align:center">*</p>

Between the time we did the research for this book and the time it was published, the COVID-19 pandemic intervened. Dealing with COVID-19 taught leaders lessons that will be useful in tackling the climate crisis:

* Steer by scientific evidence.
* Plan for economic impacts.
* Act fast, aggressively, consistently.
* Invest what it takes.
* Collaborate globally.

<p style="text-align:center">*</p>

Avery and I had help making this book from my son and my husband. They often interviewed with us, and their questions opened new avenues of exploration. Sometimes my son photographed with us. My husband edited our manuscript.

As Miranda Massie, Founder and Director of Climate Museum, told us, "It's great that this book is a multi-generational project because the crisis that we face affects all generations and we need everyone's perspective to solve it."

We are grateful to powerHouse Books for being sensitive to this book's content and intent. When they produced COOL, they used linseed oil ink and Forest Stewardship Council certified paper, which has been sustainably grown and responsibly harvested.

We hope the stories and the sections titled "Why It Matters" and "What You Can Do" will inspire you to act.

In fact, you have already taken action by buying this book, because 100% of our author royalties go to the Women's Earth Alliance to provide seed funding to women around the world who are starting businesses and nonprofits to reverse global warming. In addition, we will plant a tree for every copy of COOL that is sold.

Avery and I look forward to the existential impact that you and we are about to create together.

INTRODUCTION
Avery Sangster

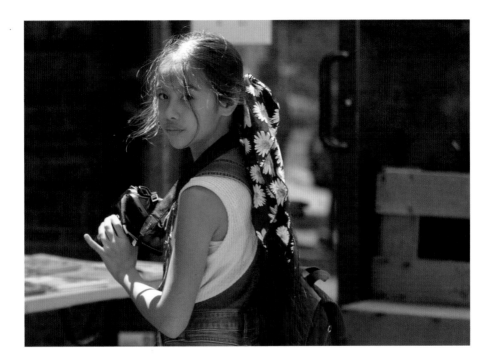

Imagine a grove of trees that provide shade for picnics, nests for birds, and places for kids to play hide & seek.

Now imagine that due to the climate crisis, the trees have died, the nests are empty, and the kids don't play here anymore.

When I imagine the death of these trees, I see the destruction of our planet permanently affecting my future and the futures of generations to come.

This doesn't have to become our reality. But we can't wait for others to figure this out for us.

We need to take action ourselves, now. Fortunately, the women leaders in this book are showing us the way. All of us will have to change the behaviors that are causing our planet to grow warmer. It won't be easy. But it is possible.

The future, and our lives, depend on it.

From Greta Thunberg's address to the United Nations' Climate Action Summit, New York City, September 23, 2019

"

The world is
waking up.
Change
is coming.

"

INCREASING

AWARENESS

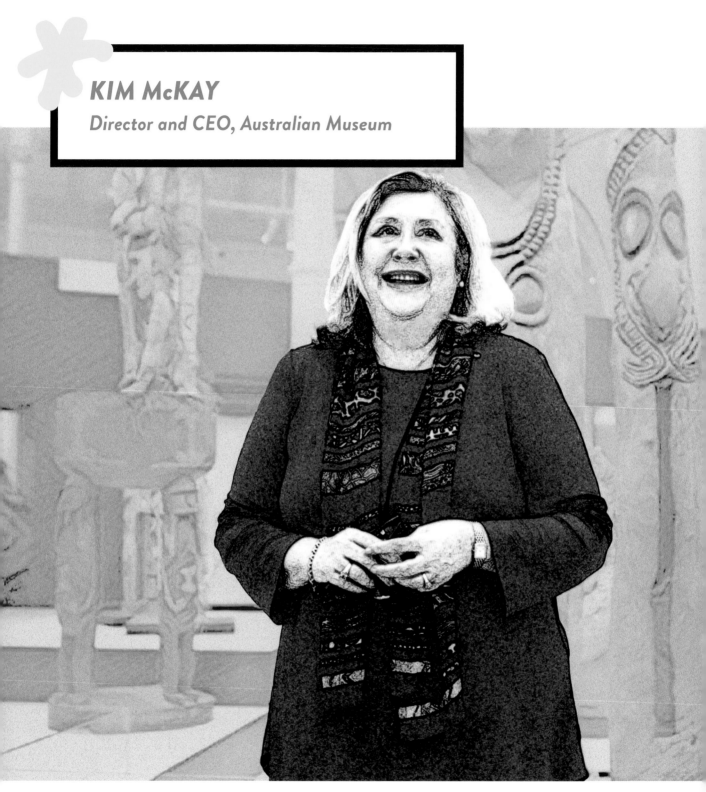

Director and CEO, Australian Museum

"My passion d

FROGS

Kim McKay is the first woman to lead Australia's oldest and most prestigious museum; she is using her position to motivate her fellow Aussies to act to reduce global warming and she has enlisted frogs to help.

Frogs, you see, are the "canaries in the coal mine" of climate change. Every aspect of their behavior, reproduction, and survival is dependent on temperature or moisture or both. Between June 2019 and February 2020, some 46 million acres burned across Australia. Some frogs handle hot, dry conditions by burrowing underground for months, even years, until rain falls. Others require cooler, wetter, rainforest conditions.

Very little is known about the impact that long periods of hot, dry conditions can have on frogs. But the Museum is building a database that will help scientists figure that out.

Where frogs are migrating, and whether some species even still exist, preoccupies researchers at Sydney's Australian Museum, which led them to launch FrogID, a country-wide citizen science project.

If you live in Australia, you can download a free app on your smartphone, and record your local, croaking frog. The GPS on your phone will tell scientists at the museum exactly where you made the recording and the unique sound will tell them what species of frog you recorded. "Frogs are identified by the calls they make, not by what they look like," Kim explains.

During the program's first year, November 2017 to November 2018, Frog ID data provided information about 41 threatened frog species. "Our data are freely available. In the future, scientists everywhere will be able to access the database," Kim says.

That first year, FrogID engaged close to 100,000 registered volunteers: families, retirees, students, park rangers, farmers and mine workers, who submitted 66,000 validated recordings, and detected 175 of Australian's 240-known native frog species.

It's no surprise that FrogID is popular with schoolteachers. And if there are no

esn't diminish."

AUSTRALIAN MUSEUM

> **"The idea of citizen science has been kicking around in scientific circles for some time, but I don't think anyone has done it on a mass scale like we've done with FrogID."**

frogs near their schools, teachers "can just call Bunnings, a hardware store chain. Bunnings will build a frog pond for any school doing FrogID. Frogs go anywhere there's water, so frogs come to those little ponds right away," Kim explains.

She goes on, "The idea of citizen science has been kicking around in scientific circles for some time, but I don't think anyone has done it on a mass scale like we've done with FrogID. I really hope that over the five years we've set out to do the project, it will be a game changer in terms of people understanding our biodiversity impacts."

Kim points out, "So much has been done to diminish scientific validity in the last 10 years. Citizen science is a great way to get people to engage and understand how important science is for our future. We're trying to make our climate change commitments at the museum as accessible and practical as possible."

Kim is the first woman director of the first museum in Australia, which was founded 192 years ago. "It took them 190 years to find me," she laughs as we sit down at a conference table surrounded by mural-sized aboriginal paintings: thousands of dots in thousands of colors.

Kim points to research that shows that "museums, particularly museums like ours, are the most trusted of all institutions. If we can get everybody in our natural history and science museums to start to move in the same direction, we can have a global voice."

Kim knows the strategic value of communications well. "I'm the first non-scientist to run the Australian Museum," she acknowledges. She has worked for the Discovery Channel and the National Geographic Channel. And she has launched and run effective environmental campaigns to clean up Sydney Harbor, Clean Up Australia, and Clean up the World.

"It's going to take a disaster to make

"My passion doesn't diminish," Kim says. "Climate change is the greatest challenge we have faced. There's big awareness of environmental issues and climate change in Australia. Our role at the museum is to shift people from being passive observers, to being more engaged and taking action.

"We have over 100 scientists working in the Australian Museum's Research Institute day in and day out. I'm committed to presenting the scientific facts so we don't have this terrible confusion about whether people should believe scientists or not. We know this information. We know climate change is in a pressure keg of time. The museum's responsibility is to talk about facts in a way that engages and inspires.

"We're creating a whole new installation on climate change. We're going to create a pop-up climate change exhibition and tour it around. We're doing some seminal public lectures that will also be podcast and broadcast on the radio, sort of like a state of the world report, but with the perspective of climate change. These will be delivered by Professor Tim Flannery, the Australian Museum's Distinguished Fellow and Australia's leading climate change advocate.

"Things are going to get bad. To see great chunks of Antarctica floating off and melting is scary stuff. Climate change could deliver a lot of negative things for us in the future. Look at the Zika virus. Look at food security. Some of our scientists are working on beetle infestation in our crops; the beetles are surviving and thriving because the climate's changed. The biosecurity issues around climate change are just enormous.

"I hate to say it's going to take a massive international disaster to make people wake up. Until things really go wrong, there won't be action because there are too many vested interests that have money and power on their side.

"We've got to be undaunted, keep our spirits and hopes up, and say, 'I'm not giving up' because the next person we talk to—or the next thing we do—could make a hell of a difference."

massive international

people wake up."

WHAT YOU CAN DO

1. "Make a commitment to reduce your consumption. How you shop; how you use energy. Can you use public transport? Change your own behavior. It starts with you," according to Kim.

2. Lobby your politicians. "Don't give up. Keep on it. They will only react if they keep hearing from constituents day in and day out on these issues."

3. "We've got a lot of power in where we invest our money. My investments are not going into fossil fuels. Consider ethical investment funds."

"We wanted to shine

SUSTAINABLE WORLD CHAMPIONS

Copenhagen aims to be net carbon neutral by 2025. It has already cut emissions 42% from 2005 levels by switching to renewables that generate heat and energy. Now, some buildings are heated by garbage burned in a new high-tech incinerator.

In Nordhavn, an industrial waterfront section that is being renovated, sits the Copenhagen International School. Twelve thousand blue solar panels almost completely cover its façade. Each is tilted to reflect light coming from different angles. The effect is like sequins, similar to the water that sparkles in front of the school.

The eight members of the school's Board of Directors – six of whom are women – hired the architects, and defined the school's vision and mission as: "Educating champions of a just and sustainable world."

I am here to meet two of those champions, both 18 years old. Anna Zaske and Leonie Wechsler escort me to the glass penthouse. On one side, we see a field of colorful shipping containers and, on the other, a canal where freighters glide past.

Each girl wears a cap that signals she has finished exams. In fact, Anna finished her last final one hour ago. They are excited about graduation, and bubbling with things to tell me about their school and their environmental work. "Global warming is a big topic here," Leonie explains.

"We are students at this wonderful school that has all these sustainable features," Leonie continues. "We wanted to shine a light on this, and encourage architects to implement some of these principles and techniques into the next buildings they create. We took leadership of this idea, and started doing sustainability tours of the school. Tourists, teachers from other schools, and architects joined us two or three times a month."

"Visiting architects," Anna says, "are most interested in the solar panels. That's what our school is famous for. I think CNN even came once. But there's

a light on this."

"These things make architects go.

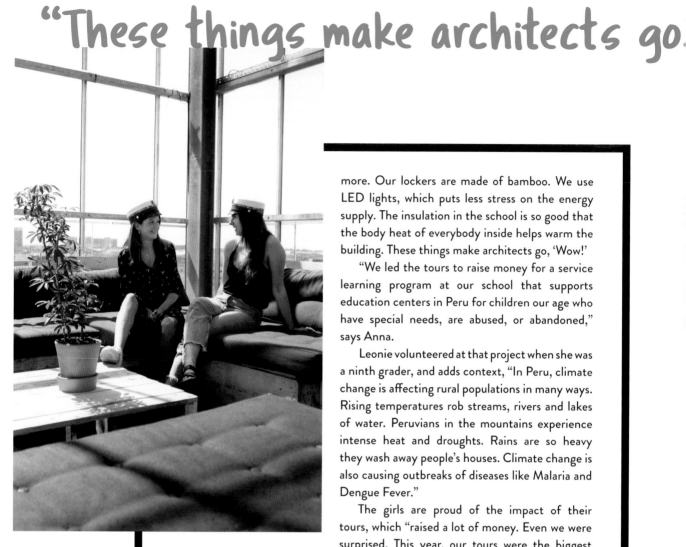

more. Our lockers are made of bamboo. We use LED lights, which puts less stress on the energy supply. The insulation in the school is so good that the body heat of everybody inside helps warm the building. These things make architects go, 'Wow!'

"We led the tours to raise money for a service learning program at our school that supports education centers in Peru for children our age who have special needs, are abused, or abandoned," says Anna.

Leonie volunteered at that project when she was a ninth grader, and adds context, "In Peru, climate change is affecting rural populations in many ways. Rising temperatures rob streams, rivers and lakes of water. Peruvians in the mountains experience intense heat and droughts. Rains are so heavy they wash away people's houses. Climate change is also causing outbreaks of diseases like Malaria and Dengue Fever."

The girls are proud of the impact of their tours, which "raised a lot of money. Even we were surprised. This year, our tours were the biggest source of income for Team Peru."

Anna's biology teacher knew she was interested in the ocean and climate change. "He suggested that I apply to be a member of the Youth Advisory Council for World Oceans Day. I got it, and worked with lots of people from different countries, all ages 17 to 23. The first thing I did was work with Leonie to organize World Oceans Day here at school."

"Isabel and Melati Wijsen, who started Bye Bye Plastic Bags in Bali, made a video for our World Oceans Day. We had Plastic Change, a Danish organization that's fighting plastic pollution. We had Aqua Jewelry, a start-up making beautiful jewelry inspired by the ocean. We had a movie screening…"

"And a Kahoot!" Leonie interjects, explaining the game, "Questions about plastic pollution would be on the big board. For example, 'How much plastic does the average Dane consume in a year?' Everyone would have red, green, yellow or blue buttons on a phone app, and would answer the question. Some really young kids, maybe five years

"Wow!'"

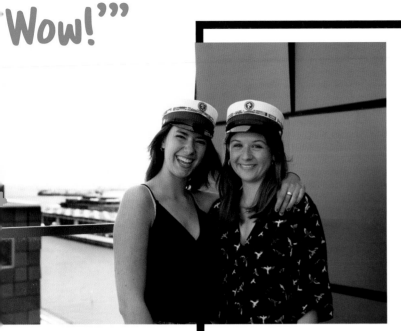

old, got into the Kahoot and earned prizes. "We got so much positive feedback!"

Anna jumps in, "People were saying, 'What are you going to do now?' We weren't expecting to continue, but we were inspired when Isabel and Melati said in their video, "You don't have a Bye Bye Plastic Bags Denmark yet." So, aha! Friends said, "We want to work on this with you. We started a chapter right away."

The projects Anna and Leonie have championed will continue after they graduate. "There will be a World Oceans Day next weekend," Anna reports. "A bunch of organizations, apartment buildings, restaurants, and cafes are showing what they're doing to contribute to sustainability and reverse climate change. It's really cool to see how they've taken over and continued our efforts!"

And Anna and Leonie will continue to be sustainable world champions for the rest of their lives.

WHAT YOU CAN DO

1. Join the Climate Strikes. Follow Greta Thunberg's Facebook page, Fridays for Future, and you'll know when and where to participate anywhere in the world.

2. Check out Green School organizations. If you're a teacher, principal, administrator, or Parent Teacher Association member, many organizations offer you everything from procurement information, curriculum ideas, and programs that engage the community: GreenSchoolAlliance.org, centerforgreenschools.org, greenschoolsini-tiative.net, projectgreenschools.org

3. When you construct or remodel a school, home, office, hospital—just about any-thing—follow LEED guidelines that create resource-efficient, healthy, cost-effec-tive buildings. For more, see leed.usgbc.org

"School Strik[e]
4 Climate"

"ACT NOW
OR
WIM LATER"

"CLIMA[TE]"

"One of the largest glob[al]

SPEAKING TRUTH TO POWER

On Friday morning August 20 2018, a 15-year-old girl climbed the steps of Parliament and sat alone with a sign that said, in Swedish, School Strike for Climate. She wanted her country to cut carbon emissions as required by the Paris Agreement. She was skipping school and her parents did not approve of that.

Little did her parents imagine that their daughter would strike every Friday. That her outrage about the climate crisis would inspire millions of children around the world to demonstrate for adult action. That she would demand change from business and political leaders at the United Nations and the World Economic Forum in Davos. That her fury would inspire young people in 22 countries to name climate change as the most important issue in the world. That she would be named *Time Magazine*'s 2019 Person of the Year and nominated for a Nobel Peace Prize.

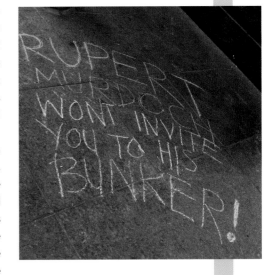

To some, Greta Thunberg seemed an unlikely candidate to lead a movement. When she first learned about climate change in school, she was so depressed that she didn't speak or eat. She has Aspergers Syndrome, a condition she acknowledges as her superpower: "I see things in black and white and don't like compromising."

She speaks bluntly and does not confuse promises with change: "You say you love your children above all else," she challenged, the first time she spoke at a UN conference in 2018. "And yet you are stealing their future in front of their

I protests in history."

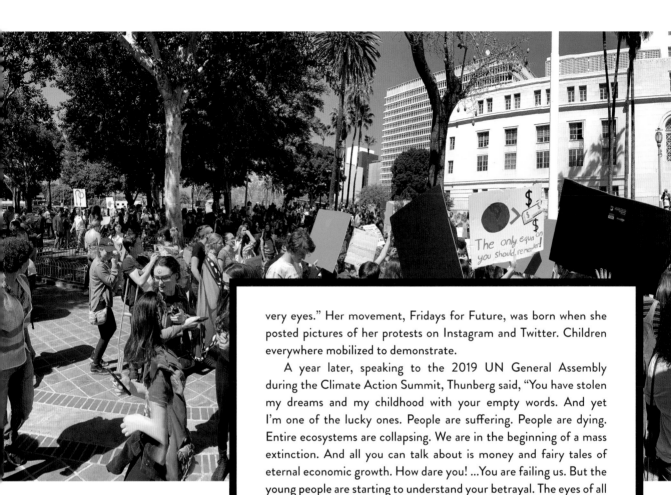

very eyes." Her movement, Fridays for Future, was born when she posted pictures of her protests on Instagram and Twitter. Children everywhere mobilized to demonstrate.

A year later, speaking to the 2019 UN General Assembly during the Climate Action Summit, Thunberg said, "You have stolen my dreams and my childhood with your empty words. And yet I'm one of the lucky ones. People are suffering. People are dying. Entire ecosystems are collapsing. We are in the beginning of a mass extinction. And all you can talk about is money and fairy tales of eternal economic growth. How dare you! ...You are failing us. But the young people are starting to understand your betrayal. The eyes of all future generations are upon you."

Between May and September 2019, Avery and I photographed youth-led Climate Strikes in Copenhagen, Denmark, Los Angeles and Mill Valley, California, and at the United Nations. We also documented the Fridays for Future protestors at a die-in at Fox News headquarters in New York City.

Our pictures hint at the international scope of Climate Strikes that continue to expand exponentially. During one week alone, September 20 to 27, 2019, demonstrations occurred in 185 locations around the world. The NGO, 350.org, estimated the number of participants at 7.6 million, and called it "one of the largest global protests in history."

Greta Thunberg claims that her activism was inspired by students at the Marjory Stoneman Douglas High School in Parkland, Florida, who mobilized to end gun violence.

Similarly, Greta inspired girls (and boys) all over the world to end climate change.

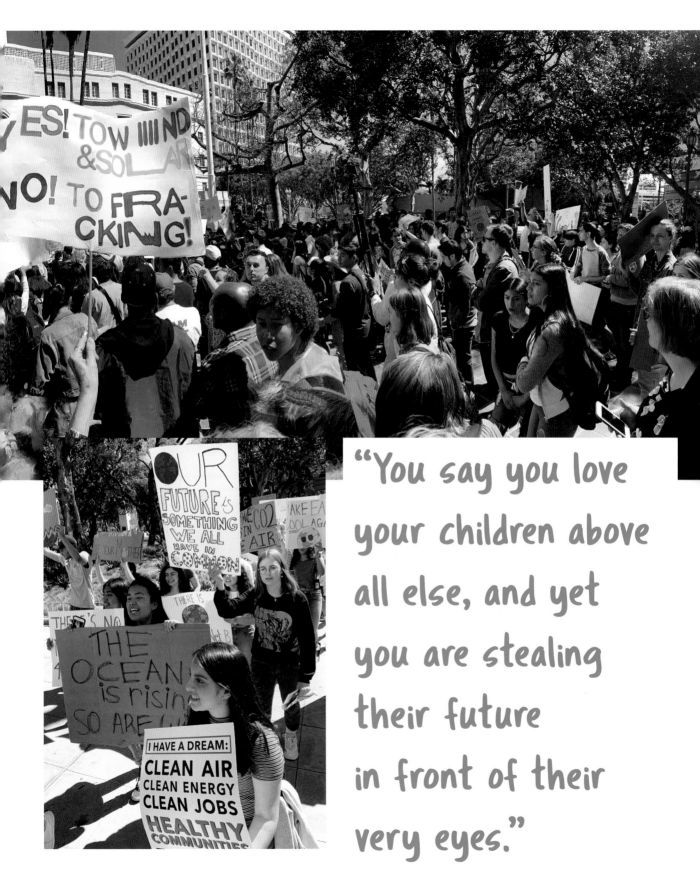

"You say you love your children above all else, and yet you are stealing their future in front of their very eyes."

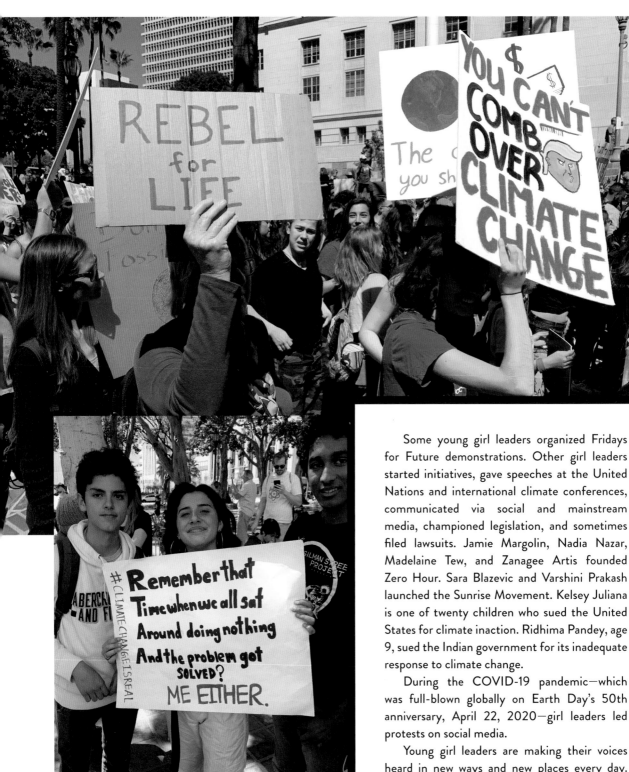

Some young girl leaders organized Fridays for Future demonstrations. Other girl leaders started initiatives, gave speeches at the United Nations and international climate conferences, communicated via social and mainstream media, championed legislation, and sometimes filed lawsuits. Jamie Margolin, Nadia Nazar, Madelaine Tew, and Zanagee Artis founded Zero Hour. Sara Blazevic and Varshini Prakash launched the Sunrise Movement. Kelsey Juliana is one of twenty children who sued the United States for climate inaction. Ridhima Pandey, age 9, sued the Indian government for its inadequate response to climate change.

During the COVID-19 pandemic—which was full-blown globally on Earth Day's 50th anniversary, April 22, 2020—girl leaders led protests on social media.

Young girl leaders are making their voices heard in new ways and new places every day. Avery and I honor and thank them for sounding a persistent, passionate, wake up call for our world.

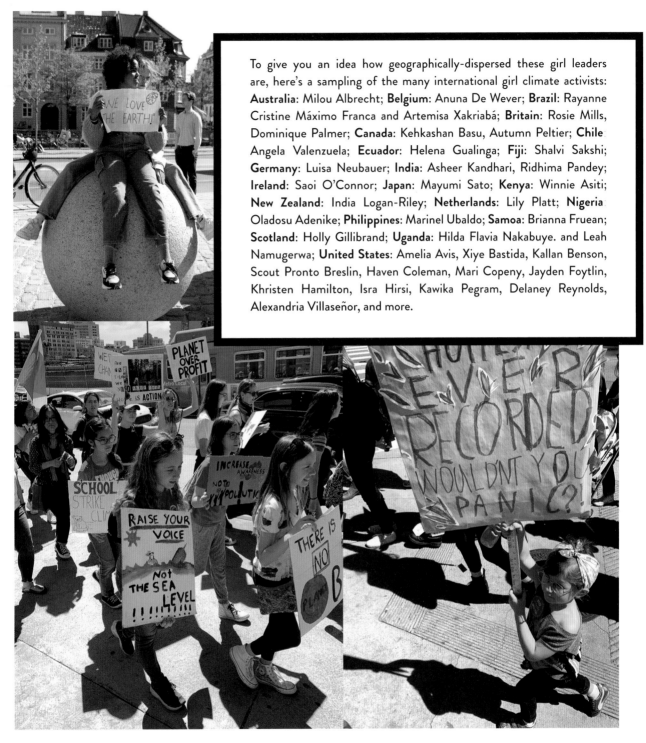

To give you an idea how geographically-dispersed these girl leaders are, here's a sampling of the many international girl climate activists: **Australia**: Milou Albrecht; **Belgium**: Anuna De Wever; **Brazil**: Rayanne Cristine Máximo Franca and Artemisa Xakriabá; **Britain**: Rosie Mills, Dominique Palmer; **Canada**: Kehkashan Basu, Autumn Peltier; **Chile**: Angela Valenzuela; **Ecuador**: Helena Gualinga; **Fiji**: Shalvi Sakshi; **Germany**: Luisa Neubauer; **India**: Asheer Kandhari, Ridhima Pandey; **Ireland**: Saoi O'Connor; **Japan**: Mayumi Sato; **Kenya**: Winnie Asiti; **New Zealand**: India Logan-Riley; **Netherlands**: Lily Platt; **Nigeria**: Oladosu Adenike; **Philippines**: Marinel Ubaldo; **Samoa**: Brianna Fruean; **Scotland**: Holly Gillibrand; **Uganda**: Hilda Flavia Nakabuye. and Leah Namugerwa; **United States**: Amelia Avis, Xiye Bastida, Kallan Benson, Scout Pronto Breslin, Haven Coleman, Mari Copeny, Jayden Foytlin, Khristen Hamilton, Isra Hirsi, Kawika Pegram, Delaney Reynolds, Alexandria Villaseñor, and more.

"The oceans are rising, so are we."

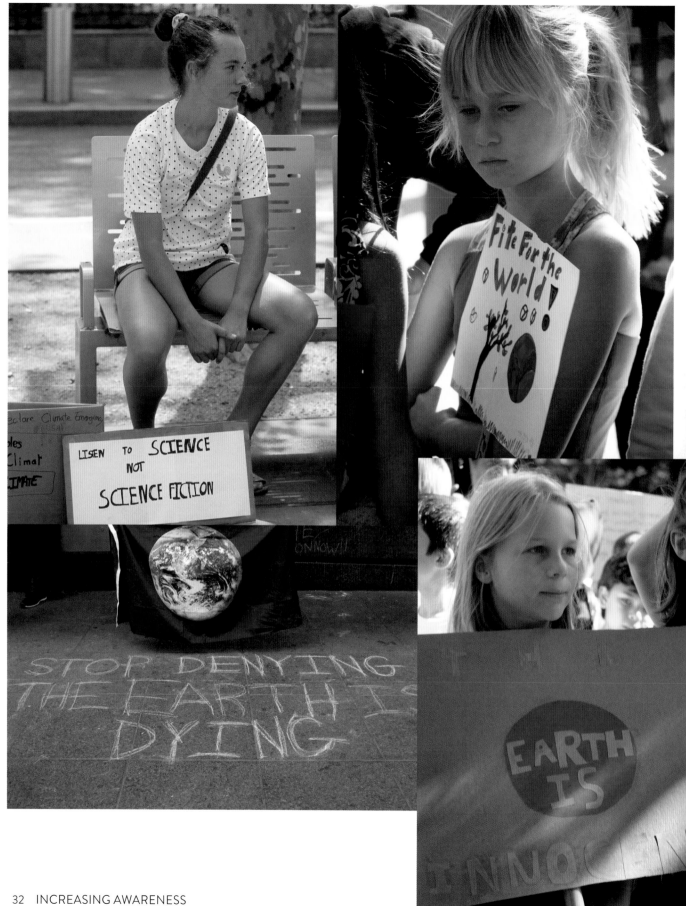

"You have stolen my dreams and my childhood with your empty words."

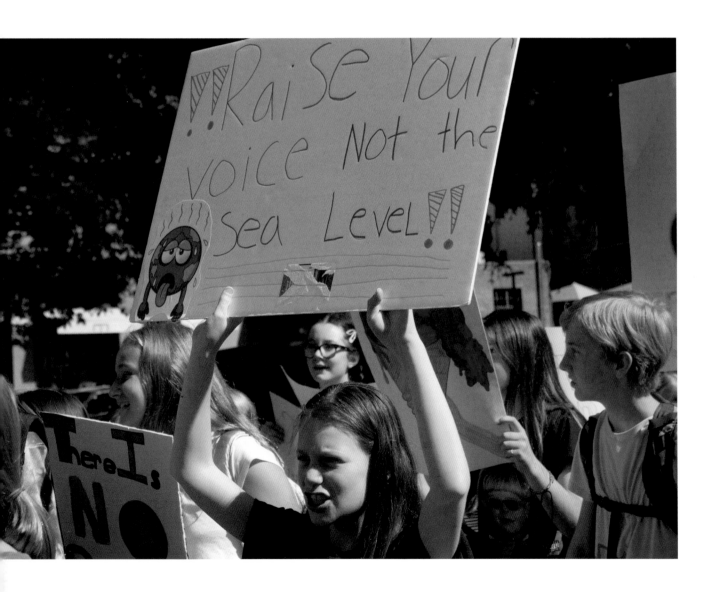

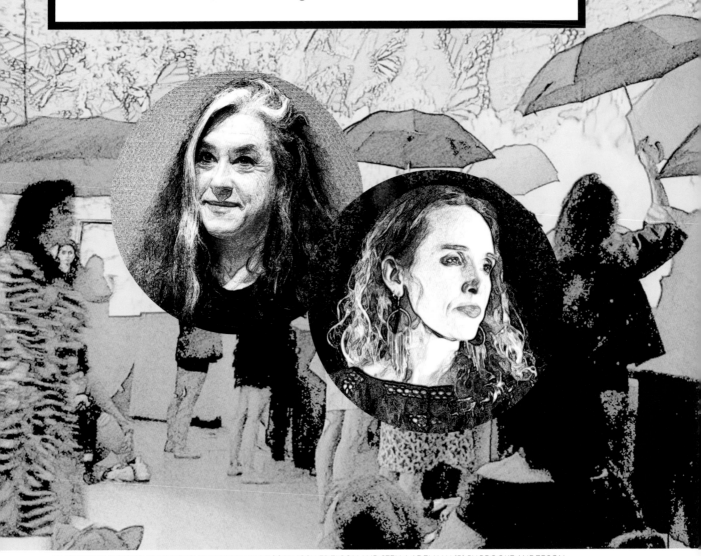

STELLA ADELMAN
Managing Director, Dance Mission Theater

KRISSY KEEFER
Artistic Director, Dance Brigade and Dance Mission Theater

ILLUSTRATIONS BASED ON PHOTOS OF KRISSY KEEFER (L) BY JOSH EDELSON AND STELLA ADELMAN (R) BY BROOKE ANDERSON.

"Our leaders

FLYING, FLOATING, FLUTTERING BUTTERFLIES FIGHT CLIMATE CHANGE

We are seated around the edges of the room. Walls are covered with projected images of butterflies sitting on, and periodically darting from, branches. *Butterfly Effect* begins. The printed program explains that the piece represents chaos theory: a small change in one place can precipitate a huge outcome elsewhere.

The butterfly that San Francisco's Dance Mission Theater alludes to this evening is Greta Thunberg, the climate activist who skipped school on Fridays to sit in front of the Swedish Parliament to protest political inaction against climate change. Her example inspired millions of protesters worldwide.

As Greta's voice is broadcast, her words are auto-typed on the walls. First, an excerpt from the speech she made at the October 2018 Climate Conference in Poland: "Our leaders have failed us."

Suddenly, the projection shifts: the butterflies are flying, floating, fluttering, and looping against blue sky. The Dance Brigade's *stormSurge* program begins.

Only women perform. First, dressed in bright disco clothes, they are seemingly oblivious to anything as dire as climate change, even though one, presciently, holds a fancy golden, dome-shaped parasol.

have failed us."

"A small change in

Another scene: dark skies are projected on the walls. The dancers wear raincoats and carry umbrellas, silhouetted as moving shadows.

That rain apparently causes flooding; the dancers strip off their raincoats to reveal black maillot bathing suits, then make sweeping, swimming motions.

For the final scene, the women are wrapped in hooded red robes that obscure their faces, and parade up and down the dance floor barefoot. One by one, they collapse.

The music stops. The lights come on. The audience is invited to move to an adjacent theater. Heading for the exit in silence, people in the audience step over the red-robed dancers' bodies, an experience I find profoundly disturbing.

In the next theater, the co-director, Stella Adelman, Managing Director of the Dance Mission Theater, comes on stage with an amplified cell phone. She calls the office of the Speaker of the House of Representatives, Nancy Pelosi, gets an after-hours recorded message, and leads the audience in a chanted voicemail: "Yes on the Green New Deal!"

When US Representative Alexandria Ocasio-Cortez introduced that bill, Speaker Pelosi denigrated it as impractical, vague, and expensive. Yet that bill—and Greta Thunberg—catapulted climate change onto the public agenda.

Krissy Keefer, Artistic Director of the Dance Mission Theater and the Dance Brigade, choreographed *Butterfly Effect*. She has been creating work about the environment and the climate crisis since 1996.

Her provocative piece demonstrates that, indeed, "a small change in one place can precipitate a huge outcome elsewhere."

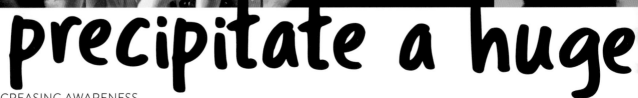

precipitate a huge

one place can

outcome elsewhere."

STELLA ADELMAN & KRISSY KEEFER 37

INVENTING

SOLUTIONS

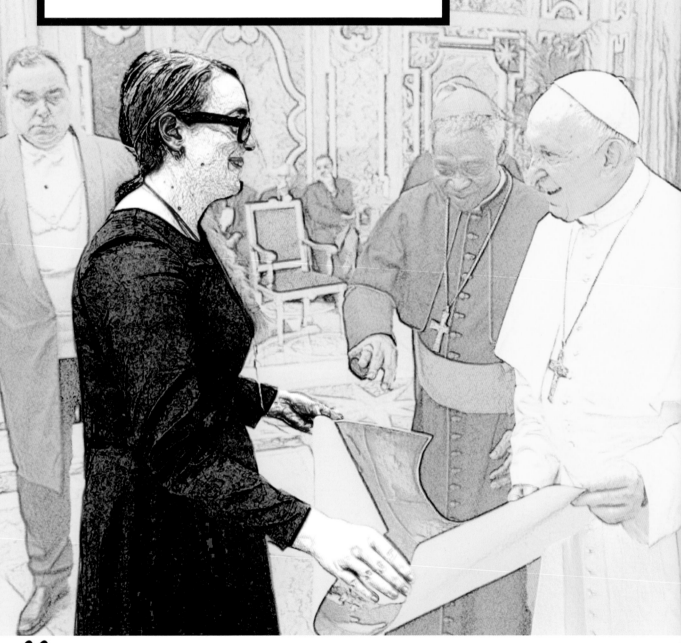

"Land is one of our mos

powerful

THINKING BIG

It's not every day that a young woman fresh out of college convinces the leader of the Roman Catholic Church to embrace her vision.

But then this was no ordinary vision. Molly Burhans imagined that the Catholic Church, which the United Nations estimates is likely the world's largest landowner, should use its property and its leadership to combat global warming. The Church's property could be used for conservation, for example, or reforestation to sequester carbon dioxide.

Molly, who considered becoming a nun, had volunteered at a convent while in graduate school. Her Masters work in Ecological Design and her undergraduate years as a biological illustrator qualified her to counsel the nuns about how to steward their property.

"I see God in nature. I can't enjoy my communion with nature when I see that it's on the brink of destruction thanks to our behaviors," Molly reflects.

"Land has a moral dimension. We are not living our mission if we aren't expressing it through the use and management of property. Land is one of our most powerful tools for change."

Less than 24 hours after graduation, Molly began working to implement her idea about the Catholic Church's environmental engagement. She had no job and no income. Someone had loaned her a house in Hartford, Connecticut where she could live and work.

Molly picked up the phone. "I started calling bishops and asking about property records. I learned that many dioceses didn't even have a spreadsheet that listed their properties. They didn't even have a list of addresses.

"I realized we had a huge data project that we had to deal with before we could do the land stuff." She went to the public library and began to collect information she could use to map the Catholic Church's properties globally. Old-fashioned maps show where places are. Molly's maps add layers of other information, which makes her maps tools for management decision-making.

In May 2015, Pope Francis released *Laudato Si'*, an encyclical that encouraged

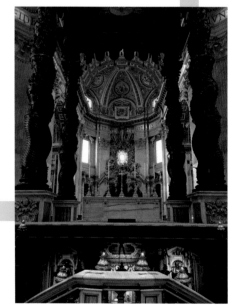

MOLLY BURHANS WITH POPE FRANCIS. ILLUSTRATION BASED ON PHOTO FROM FOTO@VATICAN MEDIA

ols for change."

> # "I see God in nature. I can't enjoy my communion with nature when I see that it's on the brink of destruction thanks to our behaviors."

Catholics to protect the earth. He wrote "many efforts to seek concrete solutions to the environmental crisis have proved ineffective, not only because of powerful opposition, but also because of a more general lack of interest." He called for a "new and universal solidarity." Molly had an ally.

That September, Molly launched GoodLands, a nonprofit that could provide information, insights, and management systems for large property owners to optimize their assets and improve the world.

"In October, a representative from Esri, the company that makes the graphic information system I was using for mapping, called to invite me to brief their CEO, to donate money and software, and to invite me to work in their Applications Prototype Lab. Once I'd gotten over the shock and recovered my voice, I said 'I'd love to, but I'd have to check with the Vatican about diocese boundaries first.'"

Molly accepted an invitation to speak in Nairobi, which made it possible to stop in Rome. "By the grace of God, I landed a meeting with Cardinal Turkson in Rome. He totally got it. We talked about *Laudato Si'* and looked at books showing Church lands. One map existed, but it wasn't global and hadn't been updated since 1901."

That was about to change. "GoodLands created the first global map of the 3,000 dioceses and filled it in with data. It allowed us to see the number of Catholics, priests, parishes, the names of bishops, auxiliary bishops, and the history of the dioceses. We were looking at the first illumination of the Catholic Church globally ever! It was wild!

"If land records were the only thing we had, that would be a big thing. But we also have a scorecard that allows us to look at 17 different things such as storm water

potential, habitat potential, conservation potential.

"The maps enabled us to see where the Church is the most important nonstate actor for biodiversity. We looked at the fragility of the political state, the percentage of Catholics in each diocese, the biodiversity in the area, and the development pressures. Now we could say, 'These are the 100 most important places where your leadership can influence people.'"

Molly premiered the maps at the Vatican in December 2016. "We displayed them in Casina Pio IV, the villa where the Pontifical Academy of Sciences is based; Galileo was its first President. You're just walking in scientific history and majesty.

"These were the first global maps of a world religion and, gosh, I was the person who made it happen! Of course I had a lot of help. But I was running things, and I had a tiger by the tail."

In July 2018, Molly had her fourth meeting with Pope Francis. GoodLands' work continues with his blessing.

I ask Molly, "In your dream, how would the Church channel its resources to combat deforestation or rising sea levels—or reduce its carbon footprint?"

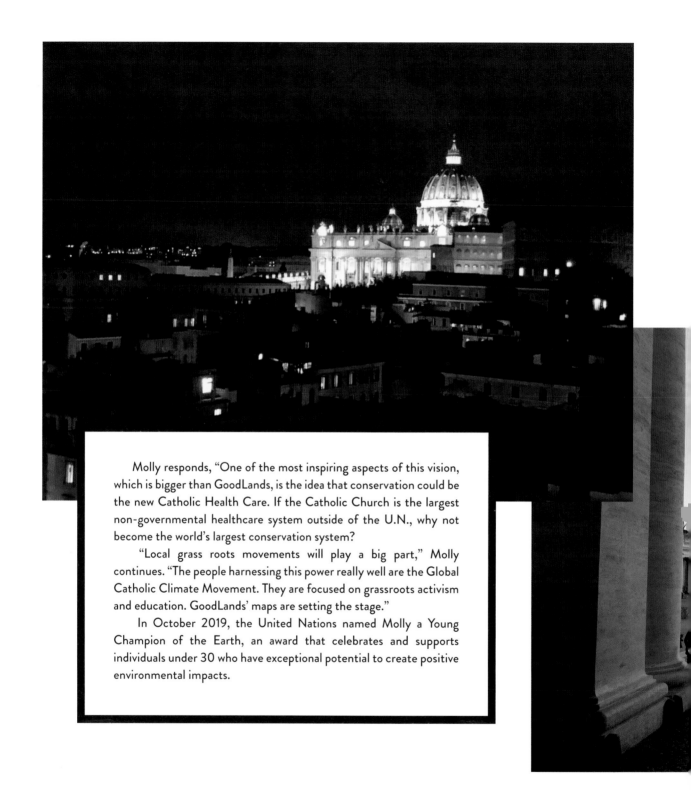

Molly responds, "One of the most inspiring aspects of this vision, which is bigger than GoodLands, is the idea that conservation could be the new Catholic Health Care. If the Catholic Church is the largest non-governmental healthcare system outside of the U.N., why not become the world's largest conservation system?

"Local grass roots movements will play a big part," Molly continues. "The people harnessing this power really well are the Global Catholic Climate Movement. They are focused on grassroots activism and education. GoodLands' maps are setting the stage."

In October 2019, the United Nations named Molly a Young Champion of the Earth, an award that celebrates and supports individuals under 30 who have exceptional potential to create positive environmental impacts.

"Conservation could be th

WHY NATURE MATTERS

Pope Francis' encyclical, "*Laudato Si': On Care for Our Common Home*" includes these ideas: "The climate is a common good, belonging to all and meant for all...Nature cannot be regarded as something separate from ourselves or as a mere setting in which we live... Leaving an inhabitable planet to future generations is, first and foremost, up to us. The issue is one that dramatically affects us, for it has to do with the ultimate meaning of our earthly sojourn."

WHAT YOU CAN DO

1. "Read about landscape ecology. If you plant trees in the wrong place, you're killing them and wasting resources."

2. "Make changes on your property to support ecosystems where you live. Understand your landscape and work with it. Don't fight it."

3. "Get involved in your city or community's planning council. Push city green plans and city green codes."

new Catholic Health Care."

"It's my

SUGAR CUBES

Imagine. Your company is counting on you to invent sustainably-sourced plastics to replace the petroleum-based plastics they've relied on for 60 years to manufacture what *Fortune* magazine named the "Toy of the Century." And your company, which was identified as having "the best corporate reputation in the world" four years in a row (including 2020), has decided to make its products 100% sustainable by 2030.

Are you up for it?

"It's my dream job," says Nelleke van der Puil, the chemical engineer who is Vice President of Materials at LEGO. "What I've always liked about chemistry is solving difficult challenges. Doing something good for the planet is important to me. It's great that I can do this with an organization that delights children – and adults – across the world.

"I have an affinity with LEGO. I didn't play with dolls when I was young," Nelleke remembers. "I built houses out of LEGOs and imagined walking through the rooms." These days, her sons are following her example, but they are using LEGO bricks to build robots.

Nelleke, who joined LEGO in 2014, says, "LEGO wants to create a positive impact; it grows out of our values. We aim to leave the planet in the best possible shape for kids. Our owners have made this a strategic priority.

"This has enabled us to attract talent from across the globe. People want to join us because we're gathering creative and scientific solutions as we go.

"LEGO has already offset 100% of the emissions its operations and suppliers create by investing $1 billion in wind farms off the coasts of Germany and the UK. We balance every kilowatt we consume with green energy, and the wind farms produce green energy on top of that." LEGO is also cutting back on plastic packaging, and plans to have 100% sustainable packaging by 2030.

dream job."

We are interviewing Nelleke at LEGO's corporate headquarters in Billund, Denmark. She pulls on her white coat and leads us into her laboratory where new bioplastics are tested for color, shininess, durability, and other qualities, all of which must replicate LEGO's high-quality conventional plastics.

In 2016, LEGO produced prototype bricks made from sustainably-sourced plastic derived from sugar cane. (Sugar cubes!)

In 2018, it introduced an entire LEGO set made from sugar cane-based plastic. The set, which included trees and shrubs, was called "Plants from Plants." It was introduced by Plantus Maximus, a superhero whose goal is to protect the planet. He challenged LEGO users to "create your own sustainability hero with Plants From Plants." People everywhere responded, posting their own superheroes online.

"Plants from Plants included more than 80 shapes," but Nelleke points out that "LEGO makes something like 4,000 shapes. We need to invent replacements for more than 20 types of plastic. When they're ready, we'll substitute them into our sets. You won't be able to tell the difference."

Bio-plastics aren't the only thing Nelleke and her team are working on. They are also finding ways to use recycled sources for materials.

Nelleke reflects that LEGO's many years of making its products the same way contributed to its corporate culture. "We are creating a new culture to deal with uncertainties: to be curious, to inspire colleagues, to engage in internal and external partnerships, to learn from our failures, to be courageous, and venture into something unknown. It's a big challenge."

There's also a big potential payoff. Nelleke points out that the suppliers who develop new bio-plastics with LEGO own the recipes and patents, so they can license them to other manufacturers.

"By changing our behaviors we enable our suppliers' other customers to take advantage of our efforts. So we're multiplying our influence."

LEGO's bio-plastics are likely to have a broad impact beyond bricks.

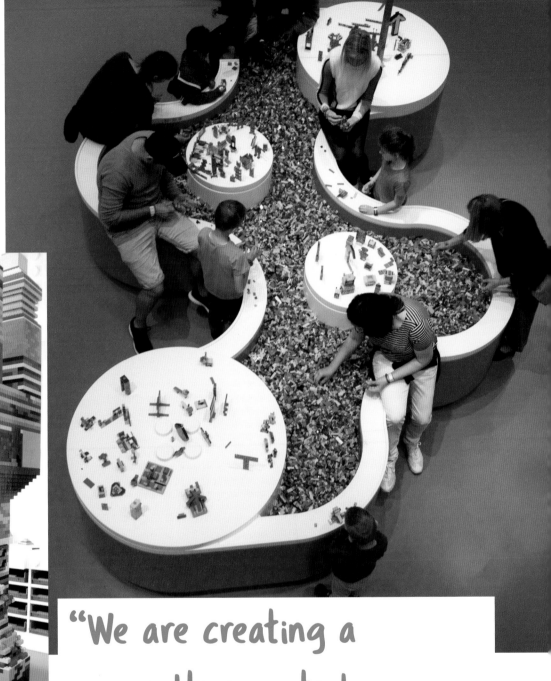

"We are creating a new culture. . .to be courageous, and venture into something unknown."

Green Zone

Blue Zone

↓

"We aim to leave the
best possible

planet in the
shape for kids."

WHY BIOPLASTIC MATTERS

Projecting the total production of plastic to be 792 million tons by 2050 and assuming that bioplastics capture a 49% share of that global market, 4.3 gigatons of carbon dioxide emissions will be avoided. This is the 47th most important step we can take to reverse global warming, according to the book *Drawdown*.

WHAT YOU CAN DO

1. Avoid single use plastics. For example, drink from the tap, not bottles. "Take a cloth bag to the store," says Nelleke.

2. When you use plastic, reuse it as much as possible; make sure it has a long life.

3. "If you no longer use your LEGOs, give them to charity. We'll help you donate them to the children who need them most," Nelleke promises. (You can print a free shipping label at GiveBackBox.com)

REDUCING

EMISSIONS

MEAGAN FALLONE

CEO, Barefoot College International

"It's a movement ar

REDUCING EMISSIONS

"Barefoot isn't just a place. It's a movement and a philosophy."

So says Meagan Fallone, the Barefoot College's Chief Executive Officer, and its imaginative driving force.

It's a movement that identifies illiterate and semi-literate women around the world who have the potential to organize and lead initiatives that reverse global warming, and then trains them at Barefoot College vocational training centers in 7 countries, to help them realize their potential.

"Today Barefoot College people work in 96 countries and train some 300 women per year as solar engineers. We call them 'Solar Mamas' and today their motto is I CAN," smiles Meagan. There are now more than 3,000 Solar Mamas around the world, teaching, learning, and leading.

"We've also added a second model. In addition to our six-month program, we now offer a condensed three-month program. These women, whom we call 'Solar Sakhis' (sakhi means friend in Hindi), go through a holistic critical thinking and entrepreneurial skills training that focuses on financial and digital literacy (designed for those who cannot read and write) so they can better sell solar home lighting products and develop other sustainable micro-enterprises.

"Since 2017, the Barefoot movement has also included a line of solar home lighting products, the first in the world to be produced, distributed, sold, installed and maintained by women. The line is called "Bindi Solar" after the dot Indian women wear on their foreheads, which represents inward and outward energy.

The Bindi Solar line's Diva Lantern was designed with direct input from Solar Mamas sitting in a circle. Meagan recalls their deliberations: "'We have to be able to hold it in our hands; it has to be this size and shape, so we can hold it in the middle.' They also wanted it to have a down light and a USB charger for their cell phones. Their perspectives were totally practical. That was a wake-up call for us.

"The real revolution was when we started to have the same women designing smartphone apps to perform transactions and data collection functions that enable them to sell—and us to learn accurately what those without access to

a philosophy."

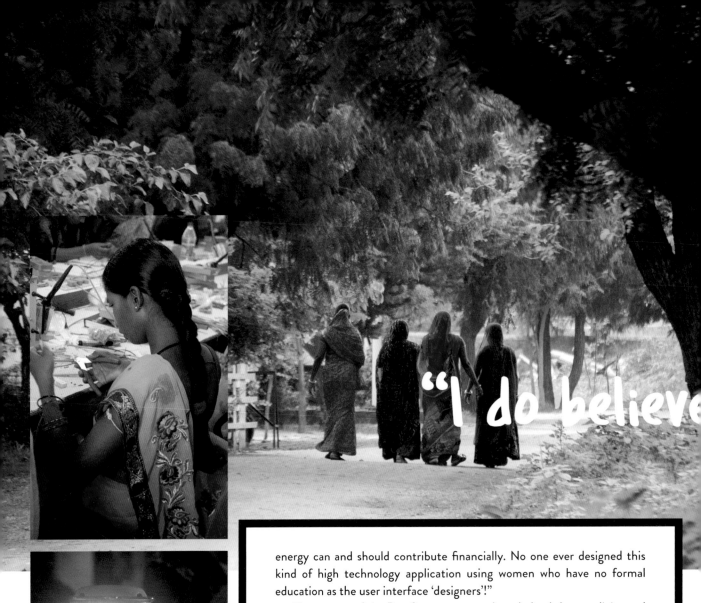

"I do believe

energy can and should contribute financially. No one ever designed this kind of high technology application using women who have no formal education as the user interface 'designers'!"

The women of the Barefoot movement have helped shape policies and programs far and wide. Mama Fatma, manager of the Barefoot College, in Zanzibar, a state in Tanzania, and her cohort Pendo provide advice and counsel to the United Nations Development Program. Fatma has been flown all over the world to conduct solar lantern training and workshops.

Meagan, who is about to leave on a trip, invites me to join her as she says goodbye to the 150 Solar Mamas and Solar Sakhis at work in three laboratories. They hail from Africa, Asia, Latin America, and India, and this morning, they are learning to build Diva Lanterns using demonstration, diagrams, and color-coding. They do not speak one another's languages. Few speak English. And yet...

As Meagan says goodbye, the women stand and sing—in English. "We shall overcome. We shall overcome. We shall overcome some day. Deep in my heart, I do believe we shall overcome some day."

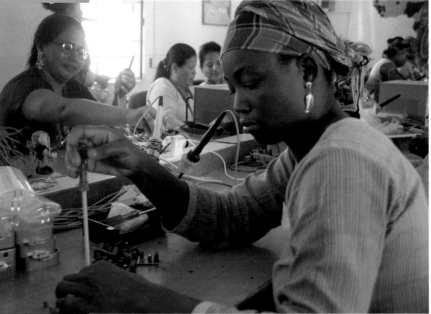
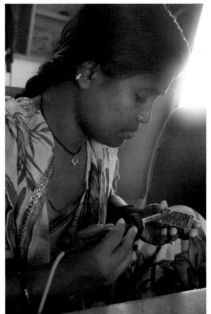

ve shall overcome some day."

WHY ROOFTOP SOLAR INSTALLATIONS MATTER

According to *Drawdown*, if by 2050 rooftop solar grows from .4% of electricity generation globally to 7%, 24.6 gigatons of emissions can be avoided. This is the 10th most important step we can take to reverse global warming.

WHAT YOU CAN DO

1. Install solar on your rooftop. Or join a community solar or coop renewable energy project.

2. Volunteer at the Barefoot College. Send your resume, skill set, interests and time commitment to: volunteer@barefootcollege.org

3. Question your elected officials about their positions on global warming and vote for those who champion policies and programs that aim to reverse it (often women).

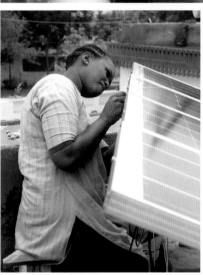

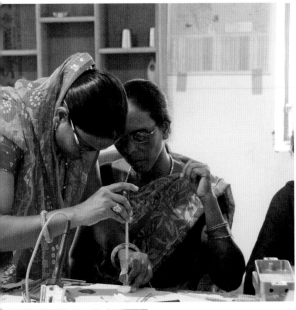

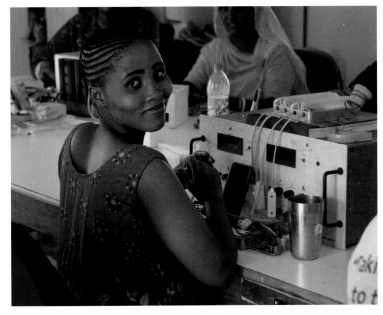

"No one ever designed this kind of high technology application using women who have no formal education as the user interface 'designers'"

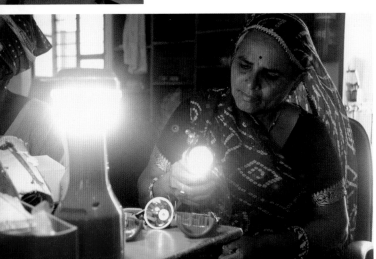

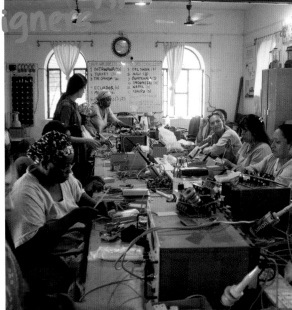

FATMA MUZO
Tanzania Country Director, Solar Sister

KATHERINE LUCEY
Founder and CEO, Solar Sister

FATMA MUZO

KATHERINE LUCEY

ILLUSTRATION OF FATMA MUZO BASED ON PHOTO BY STUART BUTLER

"Few organization and even fewer worl

LET THERE BE LIGHT!

Avery reports, "Just outside Arusha, Tanzania, we picked up Juliet William Mollel, the Maasai Solar Sister we were going to visit. She had taken a two-hour boda boda (motorcycle taxi) to come help us find her house in the village of Oljoro, because there were no road names, signs, or numbers most of the way.

"Getting there was like skiing on moguls. At first the road was bumpy with chunks of rocks. Then it was unpaved and rutted. Then the road ended but we kept on going."

Avery was about to discover why the NGO, Solar Sister, works with "last mile" communities.

Fatma Muzo, Solar Sister's Tanzania Country Director, understands what life is like for women in these communities. "Without light," she says, "there is no access to quality education or health services. In my home village, there is no electricity, but people are happy now. They have solar."

Solar Sister provides solar products to women entrepreneurs in communities where families typically use kerosene, candles, flashlights, or wood fires to light their homes.

Solar Sister's most popular product in Tanzania is a portable table lamp with a solar panel. Its women also sell telephone chargers, home lighting systems, and clean cook stoves, which run off a solar charger that can be installed outside or on the roof.

Fatma says, "What I am proudest of is Solar Sister's unique model. Few organizations work with women—and even fewer work with women and energy. Our staff is based in the communities. And that builds trust.

"It also helps with customer service and support. If one of the products goes wrong, the first to help is a Solar Sister. She will remove the product and tell us so we can respond immediately.

"When I started working with NGOs that support women, I gained a passion

work with women... with women and energy."

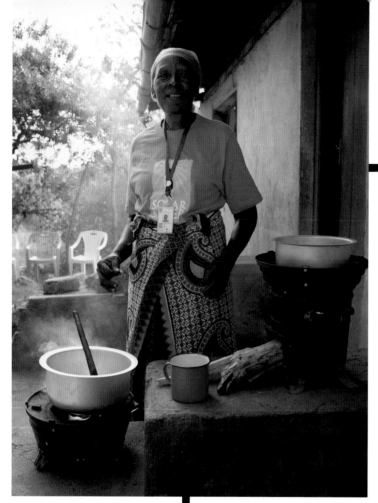

about working with women since I am a woman and I come from an African tradition where women are dominated by men.

"Many village women don't have sources of income. Maybe they have a seasonal crop business, so they have to wait to harvest and sell. But if they sell solar, they can do it every day.

"We did a survey to measure Solar Sister's impact, and it showed that our women are being respected and making family decisions. They have the same strong voices as their husbands. And many have been able to become village leaders because they are confident and empowered.

"We have worked for six years in Tanzania. The lives of the entrepreneurs who started with us are completely different. In 10 more years, Solar Sister will be self-sustaining. Our women entrepreneurs will expand their businesses and their incomes will rise. Maybe everyone will have built a new house and bought a motorcycle!"

Fatma knows too well the impact of global warming. "Climate change affects everyone. We used to get rain by the beginning of March, but this is mid-March, and we still have no rain."

She also recognizes that "many local women are not educated about the environment. They believe if they cut down a tree, another one will come up. They may have a firewood or charcoal business; if they have another income source, they don't have to cut down trees.

"We tell our Solar Sisters that we're working with them to help them preserve the environment so that everywhere can stay green. My hope is that everyone will pay attention, and we'll have a green planet."

Fatma has a request for you: "Readers can support us by understanding that women can change the world—and by spreading our voice and mission so everyone understands how important climate change is, and how important it is to include women if a country wants to grow its economy."

"I gained a passion about working with women since I am a woman and I come from an African tradition where women are dominated by men."

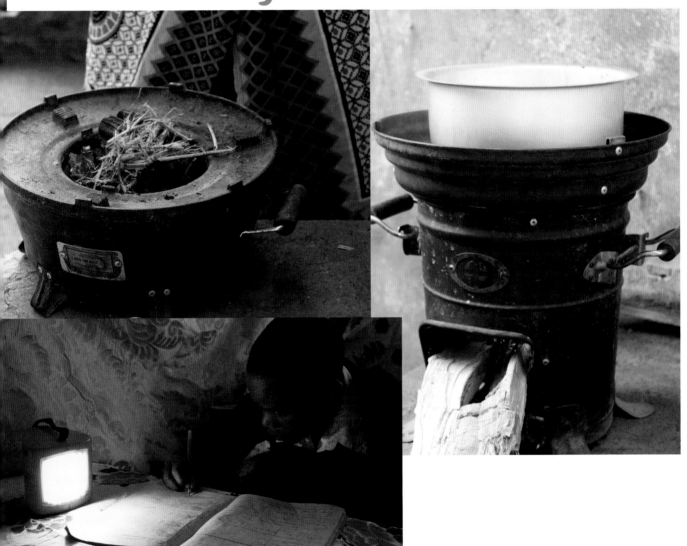

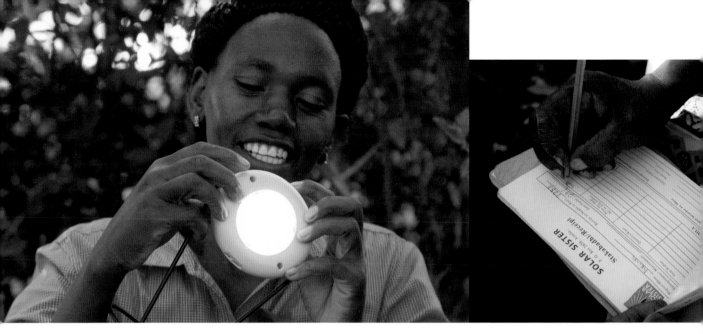

"She had used that one light to restructure her family's life."

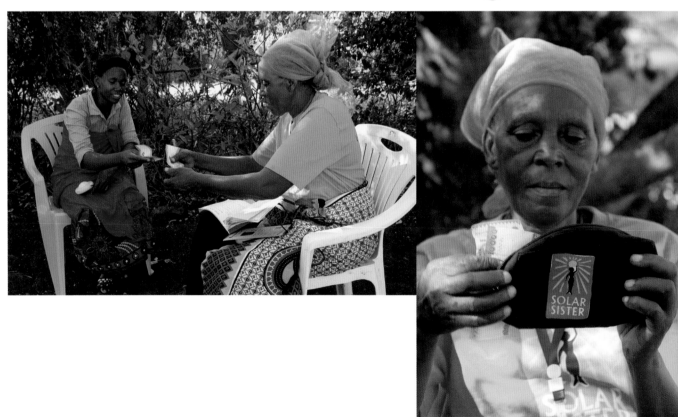

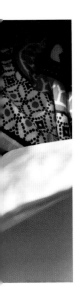

FROM FINANCING ENERGY PROJECTS TO CREATING THEM

Once upon a time Katherine Lucey worked for a bank that financed energy projects. Then Katherine encountered the Rural Electrification Agency in Uganda, which installed them.

"On a site visit, I got to see how transformative it is to have access to something as simple as light. A woman named Rebecca installed a solar light in her home. When we visited her a few years later, we discovered that she had used that one light to restructure her family's life," Katherine says.

"I thought, 'Why aren't more people doing that? Solar is affordable, available, it changes lives, it's better for the environment, better for families, better for the economics. So how can we make it happen?'

"I reached out to Sarah, head of Mothers' Union, which is like the church ladies of Uganda, and asked, 'What do you think?' She said, 'Well, I don't know if it'll work but let's try it.'

"So Sarah and I took a box of solar lamps to the top of this mountain, Kapchorwa, and met with Lydia, a local shop keeper. We gave her a box of 24 lamps and said, 'Try to sell these and if you succeed, let us know.'

"As we drive back to Kampala, Sarah gets a phone call, and it's Lydia saying, 'Okay, now what?' 'What do you mean, now what?' asks Sarah. Lydia answers, 'I sold all the lamps; now what?' I thought, 'Oh my, I have no idea.' I hadn't thought that far. So I asked Sarah to tell Lydia to send us the money and we'd send her more lanterns.

"Sarah was like, 'OK, this worked, so let's try some more.' We found ten Ugandan women who were interested in being Solar Sister entrepreneurs. We hired a local person to manage the program, and we soon had 100 entrepreneurs, then 200.

"Then the African Wildlife Foundation invited us to Tanzania. They were worried about the wildlife habitat because women were cutting down trees to make charcoal. You can't tell somebody to stop doing the job that feeds their families without giving them an alternative, so the Foundation introduced us to the women and we invited

them to become Solar Sister entrepreneurs.

"The Global Alliance for Clean Cookstoves was doing a project in Nigeria and invited us to consider having Solar Sisters sell clean cook stoves as well as solar lamps. These stoves burn charcoal and wood, but more efficiently, so they use one-third as much fuel.

"We had to withdraw from Uganda due to the political environment, but we continue to work in Tanzania and Nigeria, where we have 4,000 women entrepreneurs.

"The solar and clean cook stove products that Solar Sister has delivered since 2010 will avoid 124,855 metric tons of carbon dioxide emissions over their ten-year life span.

"I'm super proud that in 2019 Solar Sister won the Keeling Curve Prize for energy access, which is directly related to reducing the carbon dioxide emissions that cause global warming.

"Rural women are among the most affected by climate change. Most live on the edge of poverty, so the changing drought cycles put their crops and lives at risk. Solar Sister gives them some control over what happens, and makes sure that they are part of the effort to reverse global warming. We call that 'democratizing sustainable energy access: putting the power in the hands of the people who are most affected.

"Solar is amazing because everybody can be their own power plant. You can have a solar lamp, put it outside in the sun, and create all the energy you need. The power, in both senses of the word, is democratized."

Katherine's vision for Solar Sister? "By 2050, we want 10,000 women entrepreneurs bringing energy to 10 million people."

WHY SOLAR COOK STOVES MATTER

Drawdown projects that the use of clean cook stoves comprised 1.3% of the cook stove market in 2014. If adoption grows to 16% by 2050, 15.8 gigatons of carbon dioxide emissions can be reduced. This is the 21st most important step we could take to reduce global warming.

WHAT YOU CAN DO

1. "Read up. There are many smart people out there who are experts on what you're curious about," Katherine suggests.

2. "Get involved. I am a believer in solving the problem that's in front of you."

3. "Find others who share your mission and are doing good things. Look at them as role models and partners. Be inspired by them."

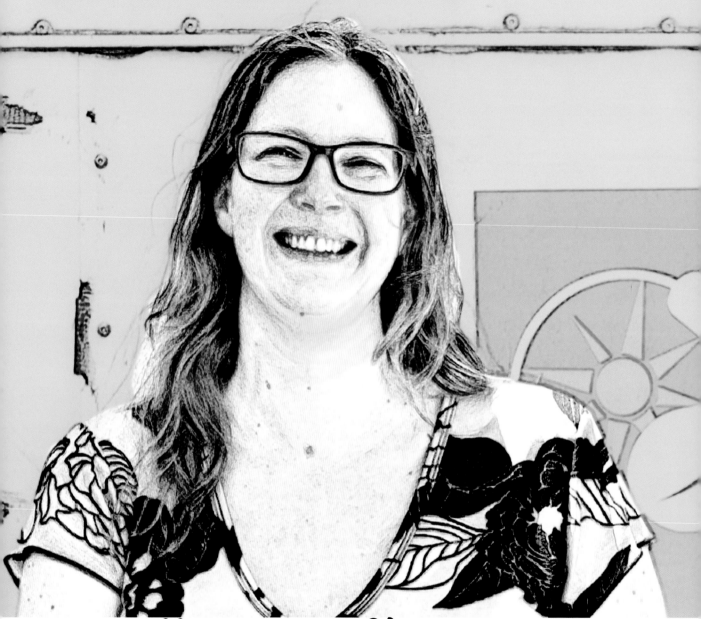

ERICA MACKIE
Co-Founder and CEO, GRID Alternatives

"We don't charge our
panels we

SOLAR REPARATIONS

"So tell me, what's so special about GRID Alternatives?" I ask.

Erica Mackie replies, "Well, for starters, it's the only nonprofit construction company on the planet that's focused on combating global warming, racism, economic inequality, and gender discrimination.

"We're also a growth company that works in the US, Mexico, Nicaragua, Nepal...so far.

"And we don't charge our customers for the solar panels we install and maintain."

How can this be?

Erica explains. "We practice what I call 'financial jujitsu.' We take money and equipment contributed by governments, financiers, utility companies, and donors like MIT and LinkedIn, and invest in local communities.

"Specifically, we invest in the people who live in these communities. We train them to install solar arrays and maintain them, though in fact they don't need much maintenance. We just tell families to hose 'em down a couple times a year, because the panels produce less power if they get dusty.

"Everything we do has a workforce development part to it. We focus on training folks who have significant barriers to employment, who have been historically under-employed, who may not have a lot of work experience.

"We've been pushing hard to change the pipeline of who's going into solar. Our head of installers is a woman based in Los Angeles. We amplify the voices of women of color who are already kicking ass in the industry. We work with 40-plus tribal communities, funding and installing their projects.

"At the end of the day, panels go on rooftops and into fields. Meters spin backwards and light bulbs go on. Which is a big deal in places that live without power. We work on Navajo reservations, for example, where thousands have never had electricity."

Since Erica and her business partner Tim Sears launched GRID Alternatives in 2001, "We have become the 'go to' place for solar companies looking for talent. In the US, jobs in solar installation are expected to double in the next several years and I read that solar employs twice as many people as the coal industry.

customers for the solar install and maintain."

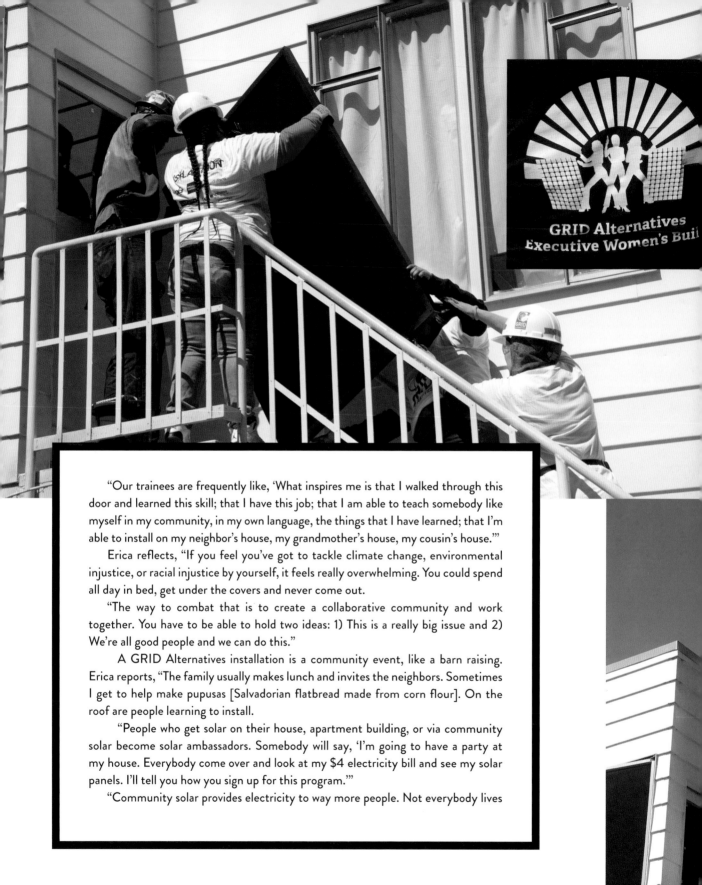

GRID Alternatives
Executive Women's Buil

"Our trainees are frequently like, 'What inspires me is that I walked through this door and learned this skill; that I have this job; that I am able to teach somebody like myself in my community, in my own language, the things that I have learned; that I'm able to install on my neighbor's house, my grandmother's house, my cousin's house.'"

Erica reflects, "If you feel you've got to tackle climate change, environmental injustice, or racial injustice by yourself, it feels really overwhelming. You could spend all day in bed, get under the covers and never come out.

"The way to combat that is to create a collaborative community and work together. You have to be able to hold two ideas: 1) This is a really big issue and 2) We're all good people and we can do this."

A GRID Alternatives installation is a community event, like a barn raising. Erica reports, "The family usually makes lunch and invites the neighbors. Sometimes I get to help make pupusas [Salvadorian flatbread made from corn flour]. On the roof are people learning to install.

"People who get solar on their house, apartment building, or via community solar become solar ambassadors. Somebody will say, 'I'm going to have a party at my house. Everybody come over and look at my $4 electricity bill and see my solar panels. I'll tell you how you sign up for this program.'"

"Community solar provides electricity to way more people. Not everybody lives

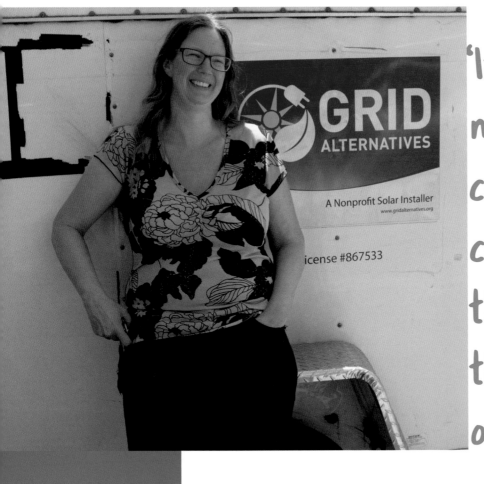

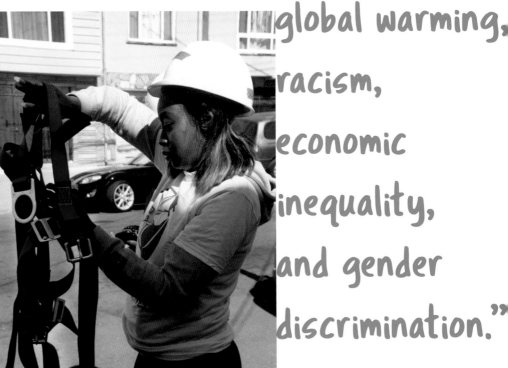

"It's the only nonprofit construction company on the planet that's focused on combating global warming, racism, economic inequality, and gender discrimination."

"We work on Navajo thousands have

in a house that's not shaded, or has a roof that's not falling down. Or even has a house. The big thing about community solar is that you can live across town, or in a different town, and your bill will go down because you own panels way over there. Sometimes we bus people to the site of the solar array to sign the back of their panels, which gives them a feeling of having an ownership stake."

For Erica Mackie, GRID Alternatives doesn't just help people. "People deserve solar and they have suffered. So I think of our work as 'solar reparations.'"

reservations, where never had electricity."

"If you feel you've got to tackle climate change, environmental injustice, or racial injustice by yourself, it feels really overwhelming. You could spend all day in bed, get under the covers and never come out... The way to combat that is to create a collaborative community and work together."

ERICA MACKIE 75

WHY SOLAR FARMS MATTER

According to *Drawdown*: if by 2050 solar farms grow from .4% of global electricity generation to 10%, 36.9 gigatons of carbon dioxide emissions can be avoided. The increase is the 9th most important step we can take to reverse global warming.

WHAT YOU CAN DO

1. "Fight for equitable climate policy. That's critical," says Erica.

2. "Listen to frontline communities. They are hardest hit and are the experts on solutions."

3. "Reduce your carbon footprint. Ride your bicycle, swap out your light bulbs, install a programmable thermostat, wear a sweater."

4. Join the groundswell of voices demanding city, state, and national policies that will reduce global warming.

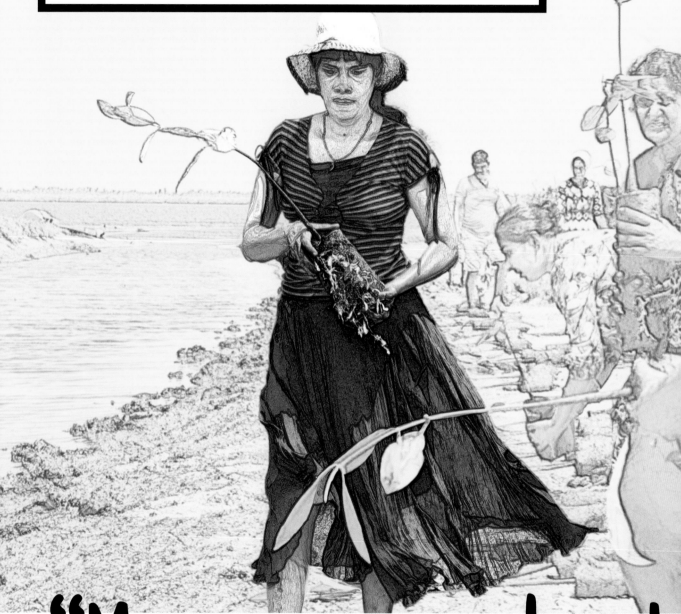

"Mangroves not only
they bury it."

THE MIRACLE TREE

"Fish come from mangrove trees," a woman told her child. "So if you want to catch fish, fish where the trees are."

Her indigenous knowledge became the seed of an endeavor that today involves some 15,000 women planting trees that do a lot more than attract fish.

Turns out mangrove trees also nurture bees, protect coral, and sequester orders of magnitude more carbon dioxide than almost any other tree.

They are miracle trees.

These women belong to a nonprofit organization, Sudeesa (Small Fishers Federation of Sri Lanka), that is based on scientists' confirmation of the unique— and uniquely beneficial—qualities of mangrove trees.

These scientists reported that mangrove trees sequester about five times more carbon dioxide than other tropical trees. They not only trap, but bury carbon dioxide below the soil.

Because global warming happens when carbon dioxide in the atmosphere prevents the sun's heat from escaping, mangroves are literally saving our lives.

The women of Sudeesa are also preventing commercial shrimp farmers from exploiting the coastal waters that could nourish their seedlings.

Thanks to their efforts, the Sri Lanka government has banned commercial shrimp farming in these waters, has provided for areas to be reclaimed, and has supported the replanting of mangrove forests.

Sudeesa includes women in every village along the Sri Lanka coastal belt. Their self-governing cooperatives now number some 15,000 women growing 100 mangrove seedlings per year in their backyards.

Members of the co-ops also monitor the mangrove forests and report anyone who tries to cut trees down. And their voices carry. Officials typically respond immediately if not sooner.

In 2000, Duane Silverstein, Executive Director of Seacology in Berkeley, California, learned about Sudeesa's work, and nominated it for the 2001 Seacology Prize. Which it won, and which led to an important collaboration as

trap carbon dioxide,

well as a 5,000 USD prize.

In 2015, Sudeesa and Seacology launched a five-year program to preserve the mangroves. The two organizations signed a Memorandum of Understanding between the Sri Lankan government, the American people (who donate to Seacology) and the Sri Lanka people to protect all mangroves. Sri Lanka became the first nation in the world to establish this policy.

Seacology has also contributed 3.4 Million USD to fund a community microcredit and skills training program organized by Sudeesa. The women attend five days of entrepreneurial skills development classes, then develop business plans.

One woman raises cows and sells dairy products. Another operates a flower nursery. Another makes and sells tools. And another sells pet birds. Each is running the business of her choice.

In exchange for the training and micro-loans, the women agree to plant, maintain, and protect mangrove trees. They plant tree seedlings along the shore once a month. It adds up. Every year, they put 1.5 million mangrove seedlings in the ground.

One morning three groups of women from the village of Mundel

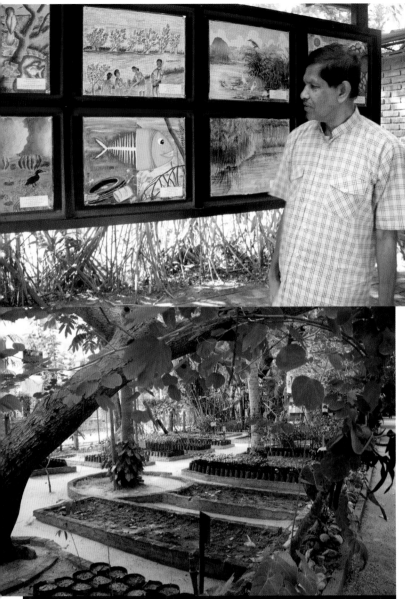

gather to plant mangrove trees. They arrive at the lagoon by boat, bicycle, and motorcycle. They are Muslim, Tamil, and Sinhalese but despite their differences, their commitment to the mangroves unites them.

Wearing bright clothes but barefooted, they embed seedlings in the dark silt at the water's edge. Then they rinse their hands and feet, roll out straw mats, open thermoses, and serve me ginger tea in china cups.

"Sudeesa works with 1,500 women-led conservation cooperatives that raise, plant, and protect mangrove trees."

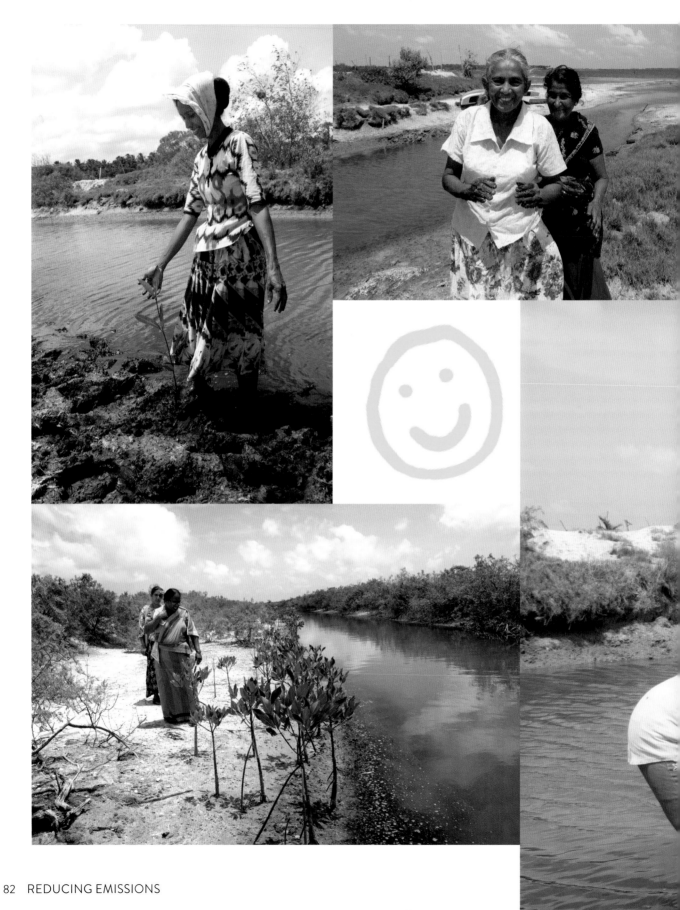

NOTE

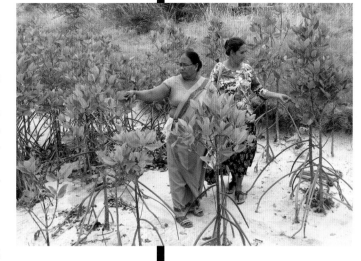

The United States National Aeronautics and Space Administration (NASA) reports that mangroves are "among the planet's best carbon scrubbers." But the tree's ability to help reverse global warming by absorbing carbon dioxide from the atmosphere and embedding it in the soil is only one of its contributions.

Mangroves emit more oxygen than many other trees.

Mangroves attract fish; the village woman who explained this to her daughter was right. The trees' stilt-like roots provide a breeding ground for oysters, crabs, lobsters, bass, trout, and many other kinds of fish.

Mangroves bolster biodiversity. Their canopies provide sanctuary for birds, bats, and bees. Ferns, orchids, and lilies thrive on their branches. They are home to endangered species of hummingbirds, sloths, turtles, and monkeys.

Mangroves can be used to make jams and juice. Their flowers can be ingredients for tea that fights inflammation and water retention in human bodies. Scientists are now conducting research to see whether mangroves can be used to treat leukemia, breast and lung cancer.

Mangroves protect the land during tsunamis and cyclones. Coral reefs and sea grass rely on the sediment under mangroves to improve water quality by sinking toxic heavy metals.

All in a day's work for a miracle tree.

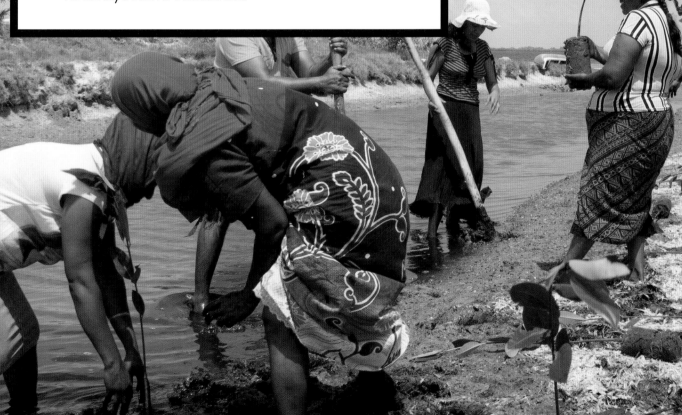

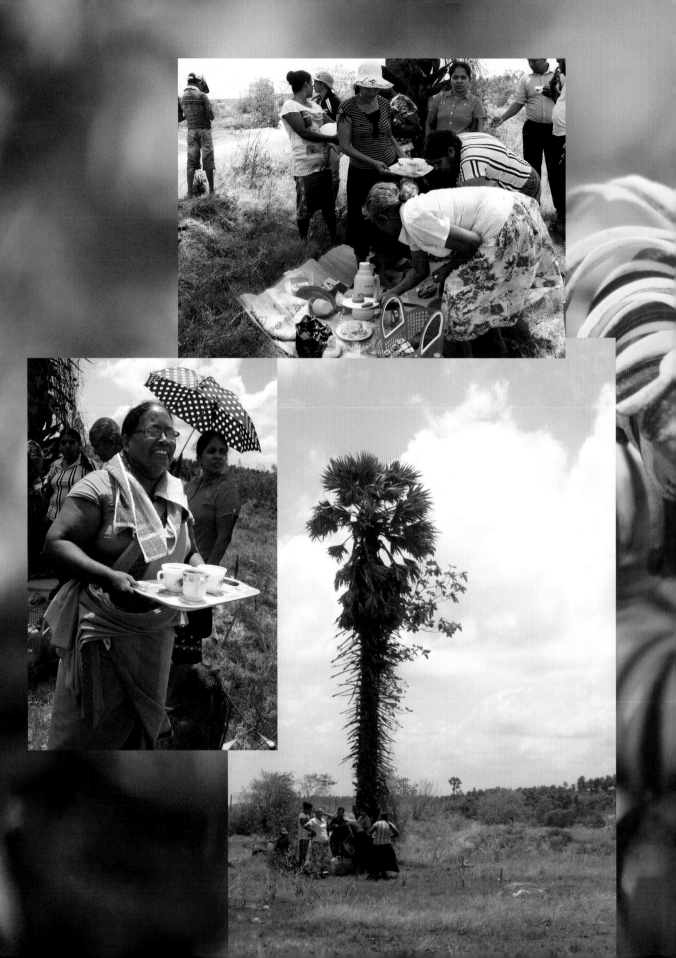

WHY MANGROVES MATTER

Mangroves grow in coastal wetland areas around the world. According to *Drawdown*, the soil of mangrove forests alone may hold the equivalent of more than two years of global carbon dioxide emissions: 22 billion tons.

Over the past few decades, more than one-third of the world's mangroves have been lost to shrimp farms, palm plantations, condominiums, and golf course developments.

Only 18 million acres of coastal wetlands are protected today; if an additional 57 million acres were protected by 2050, the equivalent of 53 gigatons of carbon dioxide emissions would be secured.

Drawdown ranks coastal wetland protection as the 52nd most important step we can take to reverse global warming.

WHAT YOU CAN DO

1. Support the Global Mangrove Alliance. One hundred species of mangroves grow in 118 countries located 25 degrees north and 25 degrees south of the Equator. The Alliance intends to increase the worldwide mangrove habitat 20% by 2030.

2. Plant bamboo, which absorbs carbon dioxide and releases 35% more oxygen into the atmosphere than an equivalent stand of hardwood trees.

3. Support efforts to save old trees; the older they are, the more greenhouse gases they sequester.

4. Donate mangrove trees to Sudeesa: 1 USD buys three trees. Email for details: info@sudeesa.lk

"Oh my goodness, I

ONE WOMAN HAS AN IDEA, AND A MILLION WOMEN EMBRACE IT. SO FAR.

When Natalie Isaacs visited London at 19, she was "excited about The Body Shop's idea of relaxation, health and happiness from within." She returned home to Australia and launched a cosmetics brand that expressed this idea. Over the next decade, she introduced three more.

"I lost my way," Natalie admits. "I was producing cheap shit covered by layers of packaging, plastic, and microbeads. I'd go to department stores at Christmas time and witness a frenzy of overconsumption. I thought 'success' meant the more money you have, the better you are. I'd sold my soul to the devil.

"I used to think climate change belonged to somebody else. I think that's the story for many of us. My husband was an environmental consultant, going off to save the planet while I didn't even have the recycling sorted."

When Natalie was in her 40s, she saw Al Gore's documentary, *An Inconvenient Truth*. Then, "As one of the world's best cosmetics salespeople, I was invited to help a company sell low-energy light bulbs. When they sold a million, they had a party, and I remember thinking, 'There's only one person in this room who's not doing anything to help the planet.' Me.

"So I had an epiphany and I changed. Once you realize these things, changing the way you live becomes an easy proposition. I decided to get our household electricity consumption down by 20%. When I saw the bill, I'd saved a heap of pollution and money just because I was more vigilant around the house. I thought, 'Oh my goodness, I am really powerful!' And if one person can do that, imagine if we all did it. Imagine!

"When I started 1 Million Women, I had no idea who the Environmental Minister was, or how to build a movement, or how to change the way you live so

am really powerful!"

it becomes the new normal.

"I looked for what the web was telling people to do, which was nothing. It was all high-level stuff, but there was no information about what one person can do. I learned that women make 85% of household decisions that affect the household's carbon footprint. In Australia at the time there was nothing that embraced that intersection between the empowerment of women and climate action. So I decided to fill that gap.

"At the beginning, we were daughters, mothers, sisters, grandmothers acting on climate change through the way we lived. My first idea was build a website, invite women to cut a ton of pollution, and get one million women members in six months.

"I was wrong because behavior change is hard to sell and stick to. I had an audacious goal, but we weren't just asking women to sign up and tick a box. We were asking them to change their way of life. In the first six months, we got 40,000 women.

"1 Million Women reaches women who want to get involved but don't know what to do. Women who are ready to move from the 'Camp of Inaction' to the 'Camp of Action.'

"I believe to truly and profoundly change the way you live you need to madly and deeply fall in love with the earth, and love it like your family and friends. It's important to really think about your relationship with the earth. We love looking at the beach, swimming in the ocean, sitting under a tree. But is it just a one-sided relationship. You can't really love the earth without giving back, and the way to give back has to be through the way you live. Everything we do can be for the good of our earth or it can contribute to climate change. Everything. So how we live is critical to the solution.

"1 Million Women is about having zero carbon lifestyles, which includes avoiding food waste and overconsumption, getting electricity usage down, using public transport, using clean energy, sustainable travel, sustainable fashion, and using your voice and vote for climate action.

"One of our key tools of engagement is our free app. Every day you can choose new bite-size actions like 'Buy experiences over items.' 'Use a fan instead of air conditioning.' 'Set up a carpool.' 'Create an Eat Me First basket in your fridge to stop food waste.' 'Take a break before you buy something and ask yourself if you really need it.'

"Our app tells you how much carbon you're saving. You can look at any country in the world, find out who else is taking the same action, and find out how much we've saved as a global movement.

"It doesn't matter if you don't know all the climate policies, or who the environment minister is. It doesn't matter if you're not up to speed with all the data. Don't worry about that. Just start acting in your own life right now. One thing will lead to another."

One thing Natalie's work has led to is awards. The United Nations Momentum for Change Award, 2013. Australian Geographic's Conservationist of the Year in 2017. The Solutions Search Global People's Choice award in 2019. Her book, *Every Woman's Guide to Saving the Planet*, had a 2021 global release.

Natalie is even prouder that, "We are now 940,000 women from every corner of the planet, of every age. We have men in our community too. We are definitely not anti-bloke, but we are a women's movement. Harnessing the unique strengths of women and changemakers of the world. I hope we'll be 2 Million Women by the time *COOL* comes out! Every one of us is the most important piece of this story."

WHY SAVING WATER
AT HOME MATTERS

Obviously, 1 Million Women doesn't focus exclusively on saving water at home. *Drawdown* examined activities such as bathing, doing laundry, flushing the toilet, and watering plants. They projected that if there were a 95% adoption of low-flow taps and showerheads by 2050, it would cut 4.6 gigatons of carbon dioxide emissions by reducing energy consumption for heating waste water.

WHAT YOU CAN DO

1. "Download the 1 Million Women app and get 12 new ideas every day (1millionwomen.com.au). Join us on all of our social media channels and help spread the word," says Natalie

2. Set your washing machine to cold.

3. Turn off your hot water heater when you're not at home.

4. Check your vehicle's tire pressure. Under-inflated tires increase fuel consumption.

5. Don't wash your dishes by hand; your dishwasher uses less energy and saves water.

6. When you order online, order in bulk (double or triple what you need at the moment) to avoid multiple deliveries.

7. Don't rake your leaves in the fall; they insulate ground that sequesters greenhouse gases.

8. Keep your smartphone a year or two longer; the manufacturing process is energy intensive.

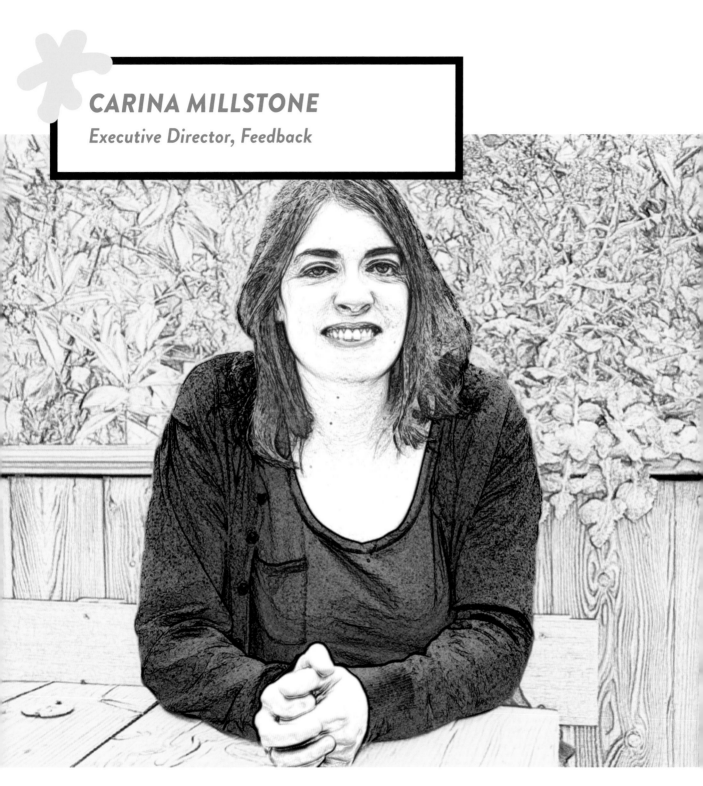

"Food waste was the

WASTE NOT, WANT NOT

Imagine you're sitting at a dinner table in Trafalgar Square, London. Your meal is the creation of a gourmet chef who used only ingredients that would have otherwise gone to waste.

It's delicious! And it's free.

You lucked out. You're attending a Feedback Feast, which the nonprofit organization Feedback has organized in 50 cities as far-flung as Prague, Nairobi, and Los Angeles to communicate the impact food waste has on global warming.

Through public events, citizen mobilization, and policy work, Feedback has taken what was a non-issue ten years ago to an issue widely recognized as an urgent priority.

Why? Because the world's food system generates about a quarter of all the greenhouse gases we humans generate annually. 25%!

Feedback is a UK-based nonprofit whose Executive Director, Carina Millstone, points out, "Before our work began, food waste was the forgotten yoghurt in the fridge. This yoghurt was a moral issue: we didn't want good food going to waste with so many still suffering from hunger or food insecurity. What Feedback brought to the fore is that food waste is also an ecological calamity.

"We were instrumental in shifting the debate about what we can do to address climate change—away from technical interventions in energy, housing, or transportation—to a focus on the food we eat. That's been a huge shift."

Carina says, "We can't move towards an ecologically sustainable society without changing our food production and delivery methods and our diets. Changing our food will release less greenhouse gases, spare land, and enable ecosystem restoration, deplete less soil, and halt species extermination."

Here are a few of the things Feedback is doing to prevent food waste.

forgotten yoghurt."

Recovering Surplus Produce From Farms

Feedback's volunteer gleaners rescue some 100 tons of fresh produce a year in the UK, and tap partners to distribute it to people in need.

Carina notes, "We give the food our gleaners bring back from the 100 farms we work with to food banks and other charities. We're also piloting two social enterprises to transform the food into products we can sell to the public."

Feedback's website says, "If surplus food is fit for human consumption, it should feed people. If not, it should be repurposed to feed livestock and fish, and finally, to feed soil through compost." This is all part of Feedback's vision of a circular food system, where people, livestock and soils are fed and replenished.

Our Economic Model

As Carina puts it, "We have an economic model that is inherently incompatible with life on earth. This is a problem because this planet is where we all live."

In her view, the food industry has sought to create an 'illusion of eternal abundance' when in fact, it has encouraged the use of more and more of the Earth's resources to drive profits. "I'm exceedingly skeptical that these businesses can help create a world where less food is wasted. Capitalism rewards growth, and we cannot have infinite growth on a finite planet."

Our Supermarkets

"In the UK, 85% of all food purchases are made at five supermarket chains. And about a quarter of the food bought from those supermarkets goes uneaten. Sure, we can encourage changes in behaviors and habits," Carina says, "but in my view it's more effective to go after the problem's source: what the companies sell us."

She continues, "We know that the most-wasted supermarket product is unsold baked goods. Supermarkets know they'll have unsold bread at the end of the day, but prefer to have customers know there will be baked goods whenever they shop."

Feedback took on the retailers. In 2018, Tesco, a leading UK grocer, committed to halving food waste in both its retail operations and supply chain. Plus, 89 major UK food businesses agreed to publish their food waste data, in addition to halving their food waste by 2030.

There is more to be done though. Carina notes, "We want to see public procurement contracts for schools, hospitals, and prisons that would also be good for the environment: contracts that would include food waste reduction targets and meals that are largely plant-based."

Feedback aims to increase consumers' understanding of food issues, and to increase people's sense of agency. To this end, Feedback seeks to replace the word "consumer" with "food citizen."

Carina believes all of us are "food citizens with the right to food...but also with responsibilities. Food is not only about personal preference; it is also a civic matter. We need to be mindful of the environmental and social implications of the foods we purchase, eat, and throw away.

"A mixture of changing current practice, putting out new ideas, a systematic critique of the current food economy, and, at the same time, piloting alternatives is, I think, the way to move us along," Carina observes.

WHY FOOD WASTE MATTERS

One third of all food is not eaten. Yet growing, processing, harvesting, shipping, and packaging food generate greenhouse gases at every stage. If we cut global food waste in half by 2050, we could save 70.54 gigatons of carbon dioxide, according to the book *Drawdown: The Most Comprehensive Plan Ever Proposed to Reverse Global Warming.*

WHAT YOU CAN DO

1. Purchase only as much food as you and your family need, and use all the food you buy.

2. Support the distribution of extra food to hospitals, schools, food banks, and charities.

3. Compost.

4. Buy food grown and distributed locally through independent shops, farmers' markets or community-supported agriculture schemes—or grow your own.

5. Organize a community feast that features food that would otherwise be wasted. Feedback offers webinars and toolkits on their website that tell how: www.feedbackglobal.org

6. Call on supermarkets and policy makers to create binding food waste reduction targets.

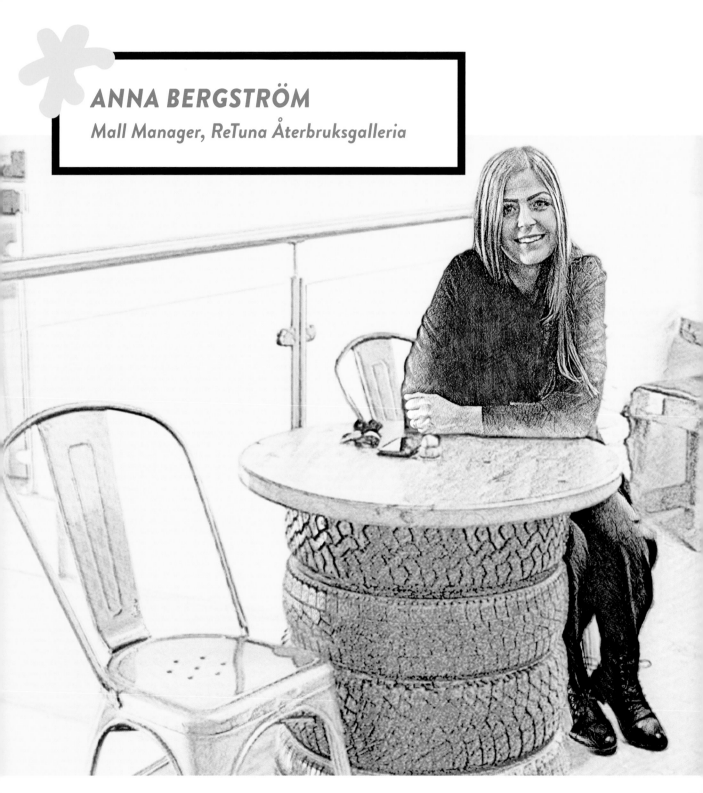

ANNA BERGSTRÖM
Mall Manager, ReTuna Återbruksgalleria

"Everyone should see wast

SECONDHAND IN HIGH HEELS

When you walk into the ReTuna shopping mall, the first thing you see is a bench that circles a tall "tree." Take a closer look, and you see that the bench is a collection of wooden chair arms, and the tree's leaves are slices of plastic soda bottles. You're looking at a creation so imaginative it could be exhibited in an art museum.

Anna Bergström, ReTuna's manager, used to manage a traditional shopping mall and, previously, a museum. She brings both areas of expertise to her work at this trend-setting mall that sells only second-hand merchandise, much of which is refurbished or redesigned.

She says, "In Sweden, we love to shop for new things. We keep something for six months, then consider it old. We might give it to someone, put it in the basement, or just throw it away."

In 2012, an official in Eskilstuna, a city an hour northeast of Stockholm Sweden, suggested that the municipality build a recycling center with a shopping mall next to it that sold recycled merchandise.

"His colleagues agreed that everyone should see waste as an unused resource," Anna remembers. The idea was to sell products residents recycled: everything from bicycles to bookcases and computers, from sweaters to hockey sticks.

Anna admits, "I was attracted to building a business to save the planet. Could there be a better business model? I don't think so!"

When she joined the company in 2015, "I had only the city's business plan and some illustrations a graphic designer had made to show people what the mall might look like."

But to Anna, the mission of the mall was enough: "We in Sweden are responsible for making recycling, sustainability, and environmental actions look so good that everyone will get jealous of us!"

as an unused resource."

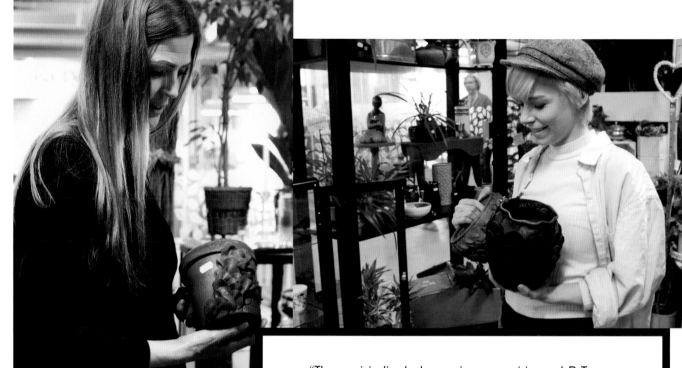

"The municipality had a naming competition and ReTuna won. 'Re' is for re-use. 'Tuna' is Eskilstuna's nickname. So 'ReTuna' means 'recycled Eskilstuna.'"

Anna's first task was to find tenants. "I toured the region to find people who wanted to make a living by opening a store in a place that was all about saving the planet.

"These people worked in their basements designing and producing products as a hobby. All of them had other jobs. When we opened, we had seven tenants.

"Today, we have 11 shops, three pop up shops, a school, conference center, and a café." Tenants pay rent to Eskilstuna, give Anna their business plans, sign three-year leases, and get the recycled products of their choice for free.

"People leave things at the city's recycling center. We upcycle them, then offer them for sale," Anna explains. "It's not about living with less. It's about doing more with what we already have."

Anna has created a new language. "The word 'recycling' is boring. 'Upcycle' is a fresher word. Second hand in high heels. This is the future of shopping malls. We are sustainable and part of saving the planet. We just need to do it in high heels—and make sure it's a popular thing to do. We need to move from waste language—to high fashion language."

Anna takes me to the flower shop and says, "This florist is an artist. She works with flowerpots. Some were in such

"I was attracted to building a business to save the planet. Could there be a better business model? I don't think so!"

bad shape that she thought she couldn't use them. Then one day she found a leather jacket in a box where tenants put things they can't use. She used it to create a flowerpot dressed in leather. Now she's famous! People come from all over to see her pots, which cost around 1500 Swedish Kronor (150 USD). That's expensive, but available only from a florist in ReTuna!"

ReTuna's school accepts 16 students for its one-year course on repairing and redesigning products. It also offers weekend classes. "If students are smart, they take the ReTuna brand with them wherever they go. People think of us as a good brand to share and be proud of," Anna says.

Every year, Anna leads two or three hundred guided tours of the mall. "I remind visitors that they can buy new things every single day with a good conscience because everything here is new—to them. That keeps things in perspective."

Anna's vision reaches beyond Eskilstuna. She smiles, "For all the companies out there who want to be sustainable, I offer a way to start a green business that will last forever, and be part of saving the planet. The companies can be a brand, be green, be happy. My goal is to have ReTuna be a sustainable destination—and to go all over the world."

WHY HOUSEHOLD RECYCLING MATTERS

According to *Drawdown*, about 50% of recycled materials currently come from households; if that increases to 65%, we will avoid 2.8 gigatons of carbon dioxide emissions by 2050.

WHAT YOU CAN DO

1. "Shop for a second-hand outfit if you want to be a better person," Anna suggests. "Start with clothes."

2. "Buy one Christmas gift that's second hand in high heels. You don't have to buy all your gifts; start with one."

3. Recycle products that you're finished with: donate them; give them as presents; hand them down.

4. Repair and refurbish clothing and furnishings when possible.

"Kailash had a visi
I invented

EDUCATING GIRLS

Nina Smith: We are focused on educating 30 million girls and boys who are now in child labor and outright slavery.

Paola: Great, but how will that help reverse global warming?

Turns out the book, *Drawdown*, has the answer. Written by climate scientists, researchers and scholars, it ranks the 80 most effective steps to reverse global warming. Number six is "educate girls."

Nina explains that educated girls are able to earn an income, and think about growing food sustainably. "They know their reproductive rights and about how to access birth control so they can choose whether to have children and how many children to have. They support their children's educations. And educated girls are better able to help their families and communities deal with climate change."

GoodWeave's founder, Kailash Satyarthi, shared the 2014 Nobel Prize with Malala Yousafzai for his work rescuing children from exploited labor. Since he founded GoodWeave in 1994, the nonprofit has been rescuing children from carpet looms in Nepal, Afghanistan, and India, and enrolling them in school. Nina smiles, "Kailash had a vision. I invented ways to realize it." She joined GoodWeave 20 years ago.

Nina arranged for me to document GoodWeave's work in India, and now GoodWeave's Navneet Singh leads me through the dirt streets of the village of Mohanpura, Rajasthan, between small, pastel-colored houses. He seems impervious to the monsoon-season heat. I am not. Earlier, the village's Headman welcomed me by placing a red bindi on my forehead. It's now smeared. My clothes are soaked.

GoodWeave has not yet launched initiatives in this village; it's immediately clear why help is needed. Navneet ducks into doorways and introduces me to women and girls who are weaving, gluing sequins on chiffon, spinning thread.

Choti has been working since she was 13. Mouli, a widow with four children,

n. ways to realize it."

"By 2020, they educated

earns $2 a day and her daughter failed tenth grade twice because she had to work to help feed the family.

These home-based workers were selected by brokers who distribute assignments for large companies located in the cities. Child labor is illegal in India, but difficult to control. These children are invisible, hidden at home, working sporadically without formal employment arrangements. Companies they work for have no idea who or where they are.

GoodWeave has just completed an assessment to identify the girls and boys in Mohanpura who are most vulnerable to becoming child laborers. GoodWeave staffers are effective sleuths, stalwart about their intention to stop labor slavery before it begins.

By 2020, they had rescued and educated 45,975 children and they are tackling child labor in industries as diverse as apparel, jewelry, brick making, home textiles, tea farming, and more.

nad rescued and
45,975 children."

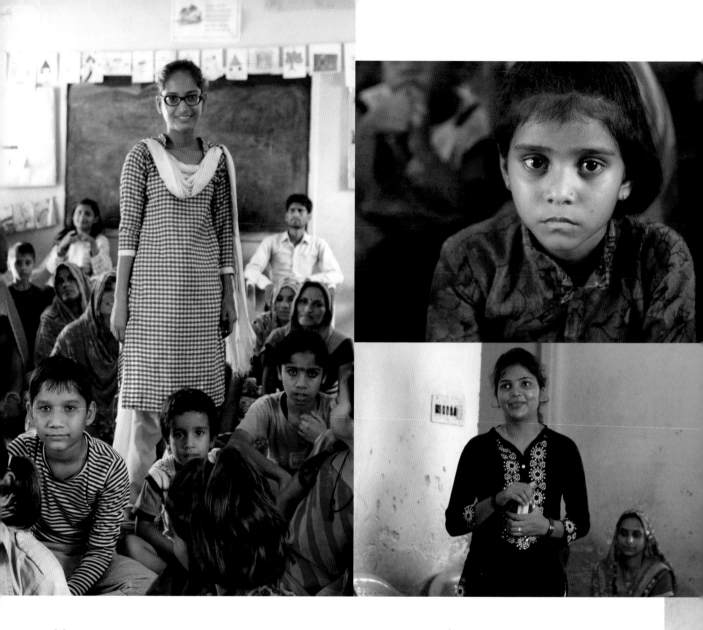

"We are focused on educating 30 million girls and boys who are now in child labor and outright slavery."

GoodWeave approaches companies with an irresistible offer: "We will take responsibility for finding and stopping illegal child labor in your supply chain if you sign a licensing agreement, and pay a licensing fee. You'll get to use the GoodWeave label, which assures your customers that you didn't use child labor to make your products, and gives you a marketing advantage. We'll invest half of the licensing fee to educate the children who used to be illegal laborers." Licensees include 180 organizations in 18 countries, among them Target, Macy's, and Restoration Hardware.

Having assured local parents that educated children will provide their families better financial support long term, GoodWeave doesn't just enroll the children in school. Its people run early childhood education centers, provide programs to help children get up to speed academically, coordinate home schooling with certified teachers, provide scholarships and sponsorships, run afterschool Motivation and Learning Camps, plus sometimes pay for uniforms, school supplies, and tuition.

When we visit Dhaula, a village where GoodWeave has been working for several years, only adult women are creating carpets and stuffing mattresses. Their daughters are in school.

The Aarti Government School in Dhaula has its motto painted on the wall: "Education is the most powerful weapon you can use to change the world."

Despite the slogan, Aarti teachers are concerned about girls' education in India, whose society is profoundly patriarchal. Girls are raped (and gang raped) so it is not safe for girls to walk to school. Many families prefer that their sons attend school; they won't benefit if their daughters are educated because wives live with their husbands' families.

GoodWeave integrates its own teachers into government schools to supplement the curriculum. We watch a GoodWeave teacher present a math lesson by having the children sing and dance about arithmetic, which inspires the students to laugh, learn, and love it. (Children in the next classroom crane to see what all the fun is about.)

Later that afternoon, we meet mothers, teachers, and primary-age children at one of GoodWeave's Motivation and Learning Camps. One girl stands proudly in her school uniform, and shows off the glasses she got because a GoodWeave staff member noticed she was nearsighted. She is now teaching her mother to read.

WHY GIRLS' EDUCATION MATTERS

If all girls in low and lower-middle income countries completed secondary school, carbon dioxide emissions would be reduced by 5.1 gigatons by 2050, according to the scientists and scholars who wrote the book, *Drawdown*. Of the 80 most important actions we could take to reverse global warming, girls' education ranks as the sixth most important step we can take.

WHAT YOU CAN DO

1. Buy products that ensure that children and natural resources are protected, not exploited.

2. Support organizations that educate girls. For example:

- Afghan Institute of Learning
- Akili Dada
- American University of Nigeria Foundation
- CAMFED: Campaign for Female Education
- Educate Girls Foundation
- Educate Girls Globally
- Girl Rising
- Girl Up
- Global Partnership for Education
- GoodWeave
- Malala Fund
- Mona Foundation
- Plan International
- Save the Children
- School Girls Unite
- SHE-CAN
- UNICEF Education Initiatives
- UN Girls Education Initiative
- Women Deliver

3. Advocate to end barriers to educating girls, specifically:

- Poverty: UN.org (see webpage titled "No Poverty. Why it matters.")
- Child Marriage: GirlsNotBrides.org
- Child Labor: GoodWeave.org

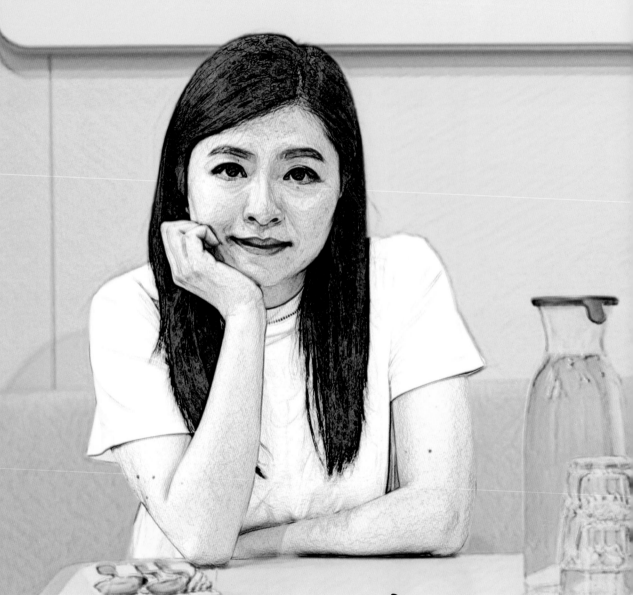

"Plant-based

WHAT A WAY TO START A WEEK!

Hong Kong residents eat more meat per capita than residents of any other city. So David Yeung faced a formidable challenge when he set out to persuade them to give up meat once a week by offering them wholesome and sustainable plant-based choices.

He launched Green Monday on Earth Day, April 22, 2012, with the intention of helping people understand that "eating green" is a cool lifestyle choice and a great way to reduce greenhouse gas emissions. (The fourth best way according to the book *Drawdown*.)

He invited long-time family friend Jenny Ng to contribute her years of marketing experience. "I knew we could package the Green Monday concept as a thematic campaign," Jenny says. Initially, she agreed to help as a volunteer during her maternity leave, having just had her second baby.

The timing was fortuitous. She had just seen Al Gore's documentary, *An Inconvenient Truth*, which was, she says, "a wake-up call."

Plus, every time Jenny and her husband had dinner with David and his wife, "David ordered vegetarian. I was intrigued. He told me about Green Monday, which he had just started, and I was so excited that every Monday I sent him pictures of what I had eaten."

Jenny joined Green Monday full time in 2013, and is now its Executive Director. "By now, I would guess 50% of the people here are aware of Green Monday. But many of them came back to us and said, 'I can't just eat salads; I don't know how to eat green. Do you have recipes?'

"We wanted to give people solutions. So we decided to start our own store, Green Common. When people consume our products, the first thing they say is, 'If plant-based food can taste this good, then I don't mind having meals like this!'"

Today, Green Common is a food boutique, a restaurant, and a lab for cooking classes. At lunch and dinnertime, the restaurant is packed with customers who enjoy a full range of delicious plant-based dishes, ranging from truffle mushroom pizza to salad made with kale, figs, kidney beans, and pine nuts.

food is delicious."

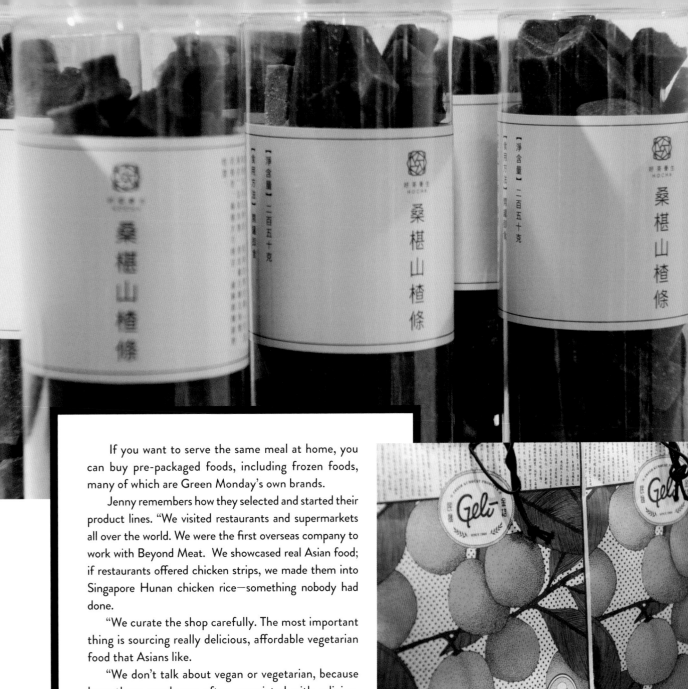

If you want to serve the same meal at home, you can buy pre-packaged foods, including frozen foods, many of which are Green Monday's own brands.

Jenny remembers how they selected and started their product lines. "We visited restaurants and supermarkets all over the world. We were the first overseas company to work with Beyond Meat. We showcased real Asian food; if restaurants offered chicken strips, we made them into Singapore Hunan chicken rice—something nobody had done.

"We curate the shop carefully. The most important thing is sourcing really delicious, affordable vegetarian food that Asians like.

"We don't talk about vegan or vegetarian, because here those words are often associated with religion. And we don't talk about 'going meatless' because we don't like face-to-face combat.

"We do like the word 'green' and the idea that green is cool. So we post signs with memorable quotes. 'Mindful eating is mindful living.' 'Be kind to every kind.' 'Kindness costs nothing.' 'ASAP means As Sustainable As Possible.'"

In addition to operating ten Green Common stores in Hong Kong, Green Monday sells plant-based products to

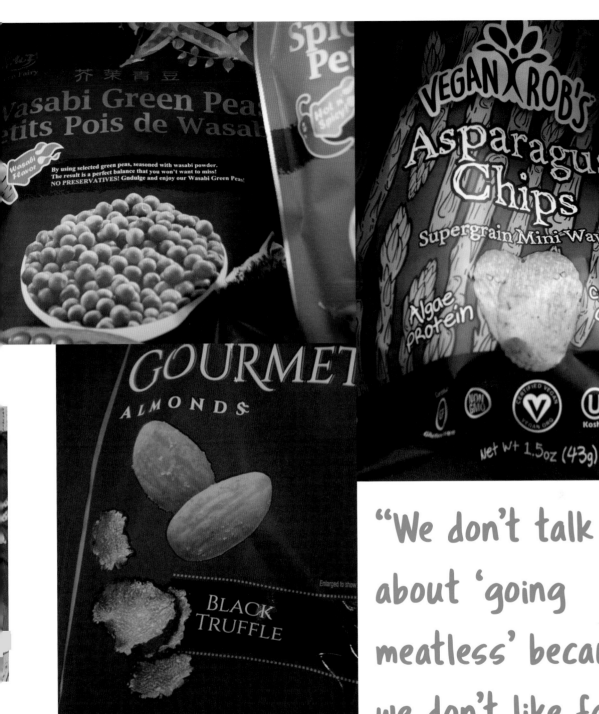

Wasabi Green Peas
etits Pois de Wasabi

Wasabi Flavor

By using selected green peas, seasoned with wasabi powder. The result is a perfect balance that you won't want to miss! NO PRESERVATIVES! Gndulge and enjoy our Wasabi Green Peas!

VEGAN ROB'S

Asparagus Chips

Supergrain Mini Waves

Algae Protein

CRISPY Good!

NON GMO

CERTIFIED VEGAN

U Kosher

Net Wt 1.5oz (43g)

GOURMET

ALMONDS

Enlarged to show

BLACK TRUFFLE

WT 5 OZ (142g) Nonpareil Almonds

"We don't talk about 'going meatless' because we don't like face-to-face combat."

"Be kind to every kind."

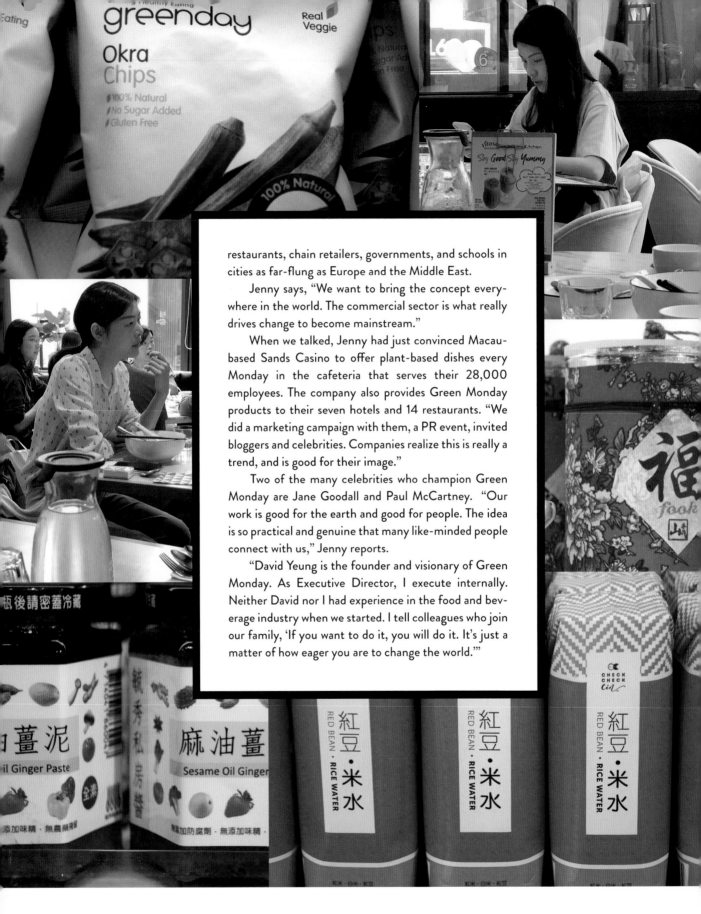

restaurants, chain retailers, governments, and schools in cities as far-flung as Europe and the Middle East.

Jenny says, "We want to bring the concept everywhere in the world. The commercial sector is what really drives change to become mainstream."

When we talked, Jenny had just convinced Macau-based Sands Casino to offer plant-based dishes every Monday in the cafeteria that serves their 28,000 employees. The company also provides Green Monday products to their seven hotels and 14 restaurants. "We did a marketing campaign with them, a PR event, invited bloggers and celebrities. Companies realize this is really a trend, and is good for their image."

Two of the many celebrities who champion Green Monday are Jane Goodall and Paul McCartney. "Our work is good for the earth and good for people. The idea is so practical and genuine that many like-minded people connect with us," Jenny reports.

"David Yeung is the founder and visionary of Green Monday. As Executive Director, I execute internally. Neither David nor I had experience in the food and beverage industry when we started. I tell colleagues who join our family, 'If you want to do it, you will do it. It's just a matter of how eager you are to change the world.'"

WHY EATING A
PLANT-BASED DIET MATTERS

By 2050, if half the world's population restricts its diet to 2,500 calories per day and reduces meat consumption, and if the related reduction in deforestation is considered, an estimated 66.11 gigatons of emissions will be avoided. Eating green is the fourth most effective step (of 80) to reverse global warming according to the book, *Drawdown*.

WHAT YOU CAN DO

1. Go Green Monday. "It's just one baby step but it's a great step," Jenny says.

2. Consider a rainbow diet to balance your nutrition. "Eat rainbow colors: red could be red beans; purple could be eggplant…"

3. Surprise your dinner guests with a green meal.

4. Check out recipes at GreenCommon.com

5. Try an Impossible Burger or Oatly Milk.

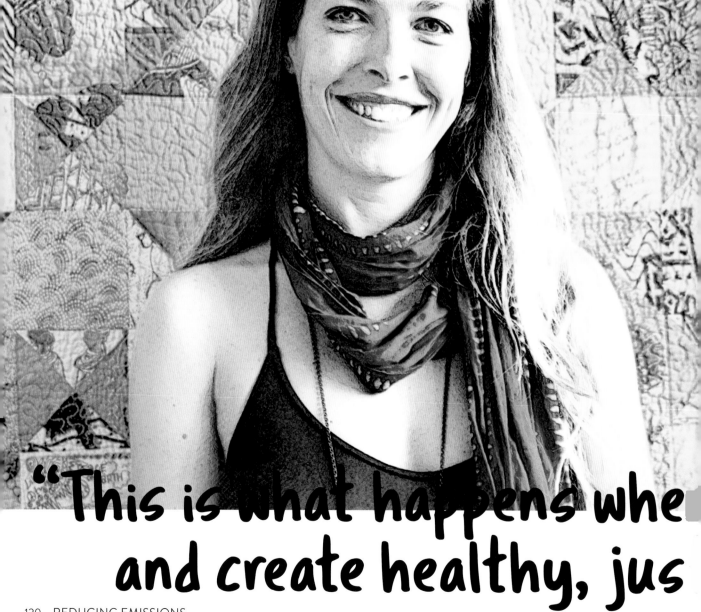

MELINDA KRAMER

Co-Founder/Co-Director, Women's Earth Alliance

"This is what happens whe
and create healthy, jus

MELINDA'S DESTINY

Some women start climate initiatives to fulfill destinies that began long ago. Melinda Kramer, Co-founder of the Women's Earth Alliance, is one of them.

Melinda was six months old when she began spending summers camping with her family in Maine. "My mother would sew sleeping bags and tents, which my father set up by the lake. We went to sleep serenaded by loons. I came to love nature, and I gained an intuitive understanding of what it means to protect what we love.

"I worked at an environmental law clinic as an undergrad. We focused mostly on a case that involved a small town and a neighboring smelter. Lead levels in the kids' blood were through the roof. Mothers organized, rallied and, in time, forced the smelter to close. I thought, 'This is what happens when women envision, demand and create healthy, just communities for our world.'

"I delved into the politics of environmental sustainability and understood that you can't separate environmental issues from their cultural contexts. I studied anthropology at the University of Nairobi, where I had an epiphany: when development work centers on women's agency, everything changes.

"In 2004, I shared my vision for uniting women leaders to protect the earth with my colleagues attending the United Nations Commission for Sustainable Development. We began to envision a global forum where women could build a power base for environmental sustainability—sharing their solutions, building alliances, and changing the world.

"We figured the best way to begin would be to gather women on the front lines of environmental and climate struggles, to envision together what this organization could look like. Thirty women from 26 countries came to Mexico City for our three-day visioning session. Aunts, uncles, friends, and donors helped pay visa fees, plane fares, room and board.

"One of my peak life experiences was standing together as a group for the first time. We formed a circle with each of us holding hands. There was a buzz of collective gratitude that you could feel in the room. My epiphany became real. The Women's Earth Alliance was born."

Shortly, Amira Diamond joined Melinda to expand WEA's programs, build

women envision, demand,
ommunities for our world."

the WEA team, and create a community of support for its work.

Today, WEA works in Asia, Africa, Latin America, and the United States to train, resource, and catalyze grassroots women's networks to protect the environment and build healthy, safe, just communities.

By 2020, over 5,000 women from 20 countries had graduated from WEA's yearlong accelerators and had gone on to launch programs reaching over 6 million people with safe water, healthy food, protected land, and clean energy.

In 2019 alone, accelerator participants launched 70 women-led initiatives that deliver benefits such as energy access, regenerative farming, and climate protection.

Working with leaders in regional hubs who understand the cultural context, WEA designs twelve-month capacity-building training sessions where women gain access to the skills and tools they need to run successful organizations: technology, entrepreneurship, advocacy, and leadership.

Participants learn to measure the impact of their work the same way WEA does: using the United Nations Sustainable Development Goals. They can say, "My Clean Cookstove project is not only reducing the number of trees being cut down, but pulling tons of carbon out of the air!"

Melinda observes, "Our solutions move from the hypothetical to the tangible, for the world to see and understand. Women are building evidence-based impact that multiplies across regions."

Each participant leaves her WEA accelerator with an action plan, seed funding, mentorship, and a global network. Participants scale their environmental projects, then teach others to do the same. Melinda says, "One becomes two, two becomes four, four becomes eight...and millions."

TWO EXAMPLES OF THE WORK BEING DONE BY GRADUATES OF WEA ACCELERATORS

Clean Cookstoves

Olanike Olugboji of Nigeria started an NGO, Women's Initiative for Sustainable Environment (WISE). As one of their flagship projects, WISE worked with Women's Earth Alliance to recruit, train, and organize 30 women leaders to sell clean cookstoves throughout northern Nigeria.

Many Nigerian women cut down trees and use the wood to cook. Olanike's project fights deforestation (Nigeria's deforestation rate is one of the highest in the world).

The book *Drawdown* ranks using clean cookstoves as the 21st most effective action we can take to reverse global warming. Only 1.3% of the world's population uses clean cookstoves now. If that number grows to 16% by 2050, reductions in carbon dioxide emissions will amount to 15.8 gigatons globally.

Forest Protection

Everlyne Namalwa of Kenya co-founded Chebich Karerwa Women Group, which has mobilized more than 1,000 women to plant indigenous trees. CKWG supplies seedlings to tree nurseries and is scaling its concept across the entire country, which has lost more than 90% of its original forest habitat.

Drawdown ranks forest protection as the 38th most effective action we can take to reverse global warming. It projects that if 687 million more acres of forest are protected (bringing the total worldwide to 2.3 billion acres), 6.2 gigatons of carbon dioxide emissions will be reduced by 2050.

WHAT YOU CAN DO

1. "Connect to your environment any way you can. Drop into nature. Fall in love with what protects us, and what we get to protect," Melinda says.

2. "Make your presence count. Get involved in organizations working to end environmental injustice. Bring your talents and resources (financial, time, skills) to efforts you're passionate about."

3. Understand that "global is local and local is global. What happens across the world profoundly influences our lives."

4. "Understand and reduce your ecological footprint. Then do a little more. In the aggregate, small steps have a huge impact."

5. "Let corporations know that you don't support single use plastic bags and bottles, GMO seeds, pesticides, fracking, and oil pipelines."

6. "Know when to speak up and when to step back. Center the voices of women, particularly frontline women and women of color. If you are one of those women, speak up and share your story."

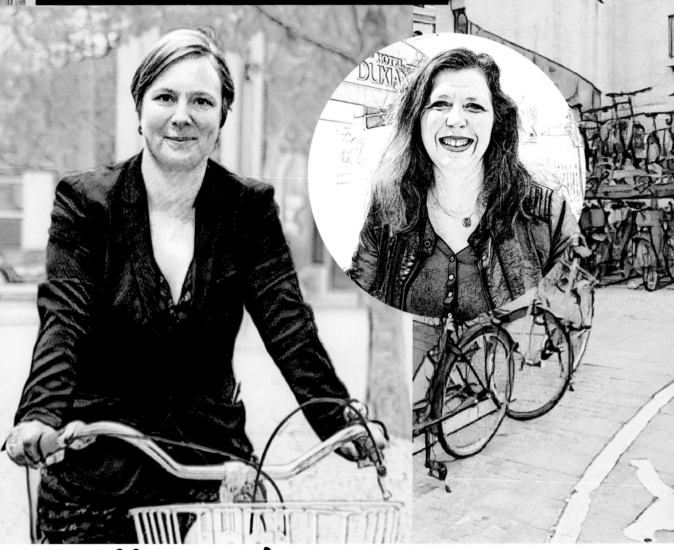

"OK, this experimen We have to do

BACKWARDS
IN HIGH HEELS

Pretend you are a city planner in a metropolis anywhere in the world. You want to cut carbon emissions by encouraging residents to ride bicycles instead of drive cars. You've decided to build a bicycle superhighway from the suburbs to downtown, but you've never planned a project like that. Job one? Call Marianne Weinreich, who chairs the Cycling Embassy of Denmark, the bicycle industry trade association that consults to cities as far flung as Bogata and Beijing.

Marianne rides her bicycle in stilettos ("It's a lot easier than walking in them!" she laughs). She has been Chairman of the Cycling Embassy of Denmark for five years, Vice Chair five years before that, and was, in fact, a founder.

There are more bicycles than people in Copenhagen. MPs ride bikes to Parliament. Vendors sell food from them. In many Danish cities, postal employees deliver mail and police patrols on them. Commuter trains have dedicated cars for passengers' bicycles, which travel free.

"Politicians, decision makers, grassroots organizations, and practitioners come to Copenhagen to study cycling. We in the cycling industry decided, 'Let's give them one door to knock on,'" Marianne remembers. There are now 40 members of the Cycling Embassy, ranging from private companies to NGOs to Danish cities, regional, and national authorities.

"The cycling community has nearly no money so we decided at least we need a cool name," Marianne admits. The Danish Ambassador to Belgium launched the Cycling Embassy of Denmark at the World Cycling Conference in Brussels in 2009. Soon, the Dutch, Germans, Japanese, and Finnish opened their own Cycling Embassies.

didn't work.
mething else."

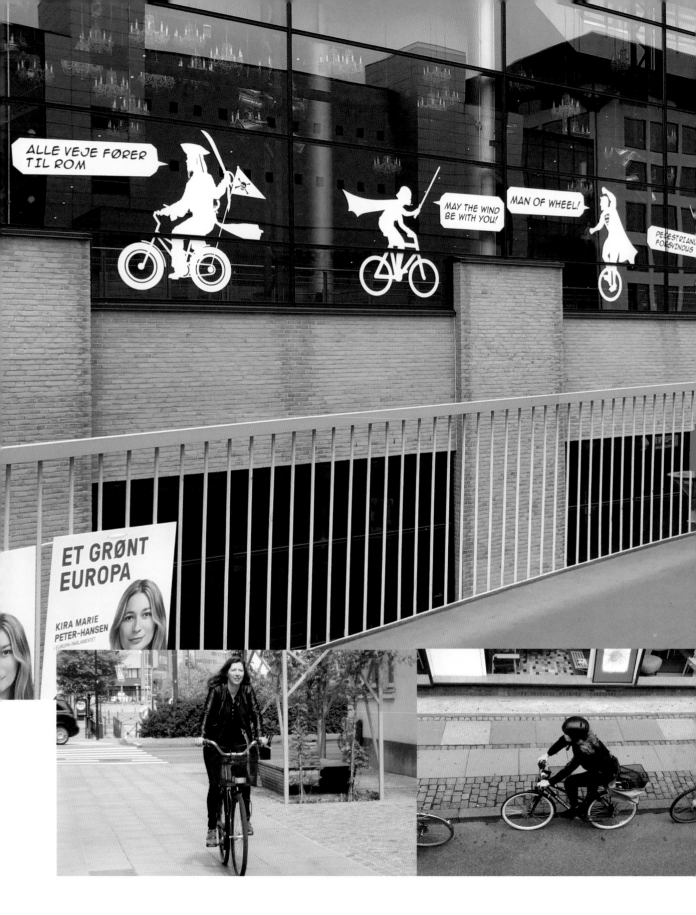

Marianne's day job is Market Manager for Ramboll, a Danish engineering and design company that works in 35 countries and plans, among other things, bicycle infrastructure. Discovering that Marianne works full time in addition to running the Cycling Embassy of Denmark, reminds me of Ginger Rogers: "She did everything Fred Astaire did backwards and in high heels."

"Since the 60s, cities have been built around cars, because people thought that was the best way for us to get around and that the car was freedom, mobility, amazing," Marianne observes. "City planners have long known that cars pollute the air; people get fat because they don't move on their own anymore; we have CO2 emissions; we get stuck because traffic doesn't move. So we think, 'OK, this experiment didn't work. We have to do something else.'

"That's where the bicycle comes in," she continues. "That is smart mobility in cities. It's noiseless, you get exercise, and you go fast and easy through the city. And people interact with each other.

"Plus, it's clean and green. In general, nobody questions anymore that we have to do something about climate change. The sense of urgency that we should have had 20 years ago is finally here.

"I am proud that the Cycling Embassy welcomes cities, gives them tours and presentations, shows them how it works in a Cycling City, and inspires people to find solutions that fit in their local context. Cities we've worked with include New York, Chicago, San Francisco, plus cities in Africa, Asia and Latin America."

Right now, 49% of all the people who work and study in Copenhagen cycle to work. The objective is to convert commuters who travel to the city by car. The Cycling Superhighway Secretariat is coordinating the bicycle super highways, direct protected routes that link 26 residential suburbs to downtown Copenhagen. "One measure that makes it more attractive to ride a bike longer distances, are Green Waves," Marianne explains. "Lights in the intersections are timed to your cycling speed so you can go through without stopping.

"The goal is not just to have people on bikes. That's a means to a bigger end: livable cities, healthy cities, sustainable cities without congestion where people can move, have space, and have good lives."

RAIN OR SHINE

Marie Kåstrup is Vice Chair of the Cycling Embassy of Denmark. In addition, for the last five years, she has headed the City of Copenhagen's Bicycle Program.

She learned to ride a bike when she was three, and her daughter learned at one and a half, thanks to a Balance Bike, which has no pedals. Marie has no driver's license and has never owned a car.

Marie recounts, "Copenhagen has had a strong cycling culture for over 100 years. A core value in Danish society is to get fresh air, be physically active, and to offer public access to our cities and countryside to everyone, no matter their age, gender or income level.

"When the bicycle started booming as a mode of mass transportation in the 20s and 30s, people saw it as authentic, healthy, and democratic, whereas cars were seen as excessive, rich people showing off, noisy and polluting."

Still, the number of cars grew in the 60s and 70s. But in the following decade, the environmental movement catalyzed "massive demonstrations; 100,000 citizens in front of city hall saying, 'We want our streets back.' They got them. Today, there are five times as many bikes as cars in Copenhagen, and twenty-eight percent of all trips to, from and in the city, are done by bike."

Marie observes, "Visitors think cycling is something you do on a Sunday when the weather's good, a leisure activity. Or they think it's a sports activity: you need special clothing, a really expensive bike, and you go to the cycle club. Or it's the bike messengers, the fearless males who ride."

Marie, who bikes through rain and snow, rides a heavy but practical step-through bike that has iffy brakes and three gears. "In Copenhagen," she says, "bicycling is not a religion. It has remained a normal thing to do, like brushing your teeth. Riders don't think of themselves as cyclists anymore than they think of themselves as tooth brushers. Copenhageners take the bike to work because it's easy, fast, and flexible. Another day, they might take the metro. On the weekend, they might take the car."

"To reduce emissions to look at clear

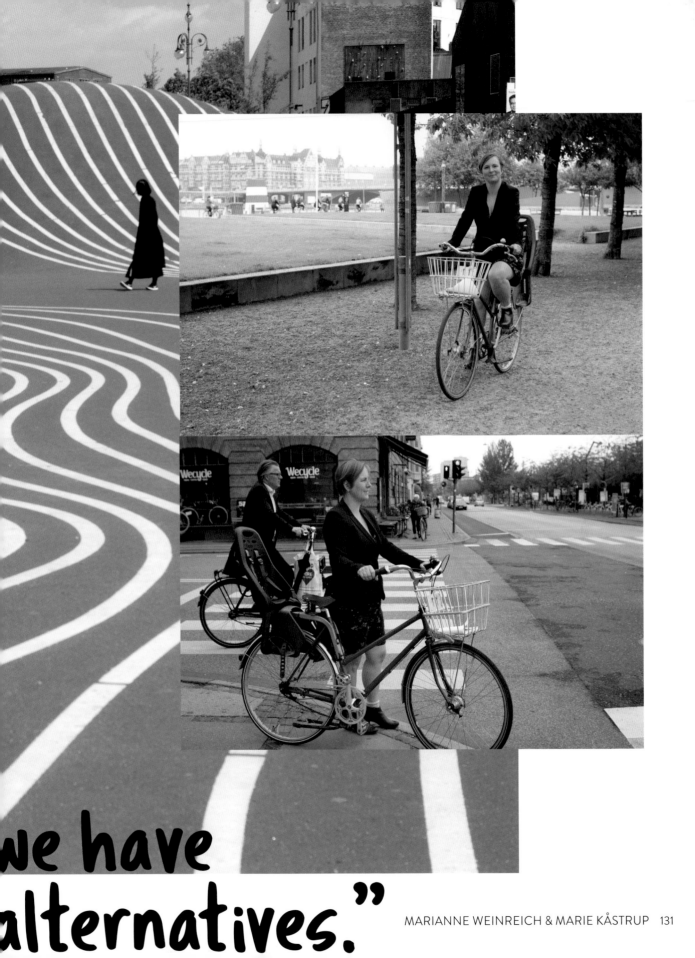

we have
alternatives."

Marie anticipates, "If we are to reduce the emissions from transportation, we have to look at clean alternatives. Cycling emits the least CO2. Electrical cars, public transportation, and walking will also be part of the green solution. But it's not like we sacrifice quality of life, and only chose to bicycle to save the planet. No! We get a better life out of it."

Europe is preparing for a future with more bicycles. The Handshake Project is a collaboration among 13 European cities. Three Cycling Capitals share best practices and mentor the 10 cities that envision themselves as Future Cycling Capitals. Copenhagen is mentoring three cities: Helsinki, Finland; Riga, Latvia; Manchester, England.

Marie relishes the alliance: "Copenhagen is really good at making attractive cycling conditions. We have separate bicycle infrastructure with curbs extending 380 kilometers (236 miles) of one-way bicycle tracks on each side of the street covering nearly all major roads. Protected infrastructure is crucial if you want cycling to be acceptable for the broad population."

Copenhagen can also advise its mentees to teach children to cycle at an early age. Marie smiles, "In Faelledparken, there is a traffic playground, a mini-traffic universe for kids with real small streets, traffic signs and lights, even pedestrian crossings. Children come with their bikes (or they can borrow a free bike) and learn all the traffic rules. They love it! They have control over themselves and they can go really fast. They love speed, and with their increasing capacity to control their bikes and handle traffic, it's a joyful thing."

Speaking of joyful things, Copenhagen was chosen to host the Tour de France for the second time. The grand departure will be July 1, 2022.

"Bicycling it's easy,

WHY BICYCLING MATTERS

In 2014, just 5.5% of all urban trips globally were completed by bicycle. *Drawdown*'s scientists and experts say a rise to 7.5% by 2050 would avoid 2.3 gigatons of carbon dioxide emissions from cars.

WHAT YOU CAN DO

1. Consider your trip. Ask yourself whether you could walk, bicycle, or take the bus. You don't have to bike everyday; just days when the sun shines.

2. Start your children cycling. All cities have parks and playgrounds where youngsters can practice.

3. Demand protected bike lanes, bike education programs, and bike-share programs if your community does not have them.

TWO PHOTOS OF BICYCLES IN SNOW BY URSLA BACH

is not a religion...
fast and flexible."

MARIANNE WEINREICH & MARIE KÅSTRUP 133

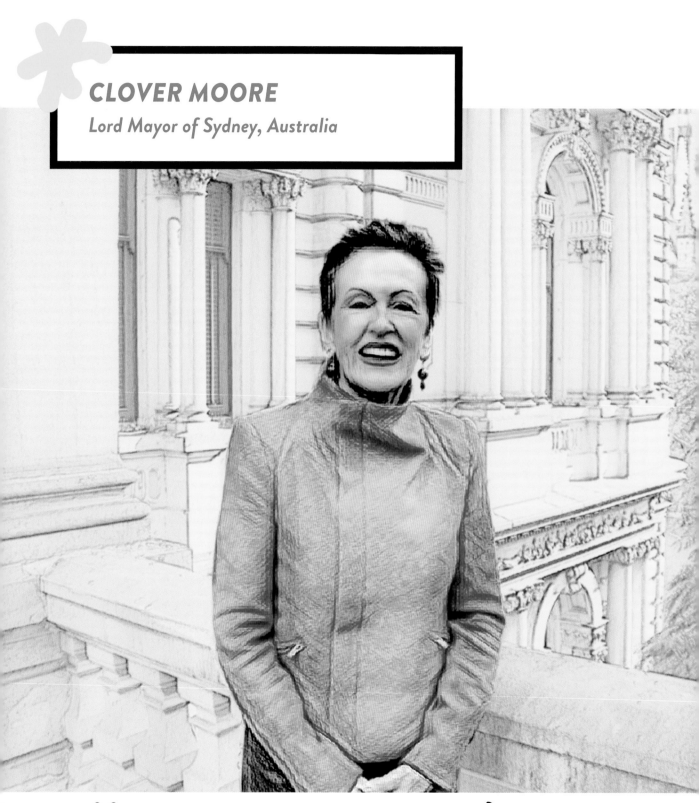

"We have planted more

THE SCARLET PIMPERNEL OF NEPTUNE

Once she led the Scarlet Pimpernels of Neptune...

Now Lord Mayor Clover Moore leads one of the world's great cities, Sydney, Australia, and is the longest serving mayor in its 179-year history.

As a child, the mayor-to-be showed two qualities that have served her and her fellow Sydney residents ever since: an ability to convince others to follow her lead and join her initiatives (like The Scarlet Pimpernels of Neptune when she led schoolmates on walks to Lane Cove National Park) and a passion for her natural surroundings (which prompted her as a child to give her parents trees as birthday gifts).

When Clover and her husband moved to a Sydney suburb in the 1970s, she recalls, "It was bleak. The park was a dust covered concrete slab. South Sydney refused to lay grass because it would be 'too difficult to sweep broken glass.' When local council elections in 1980 came around, I asked who would stand to take our concerns directly to the council. No one volunteered. So I stood, even though I had no political experience or allies, and to everyone's surprise, including my own, I won a seat. Other councilors were men with red complexions and red eyes—very different from the current City of Sydney Council where seven of ten are women.

"I had no idea that would begin a political career. But I've always been motivated by the same ideals: wonderful public spaces, planting grass, trees and bushes, and climate action. They've been central to what I've done ever since.

"After I was elected Mayor in 2004, we started the largest community consultation in Sydney's history to establish Sustainable Sydney 2030. It's shaped everything we've done. It allowed us to set ambitious goals, and stick to them.

"We have planted more than 13,100 street trees. We'll boost the size of our green canopy 50 percent over the next 15 years. Sydney launched Australia's first green roofs and walls policy with guidelines to help private development

han 13,100 street trees."

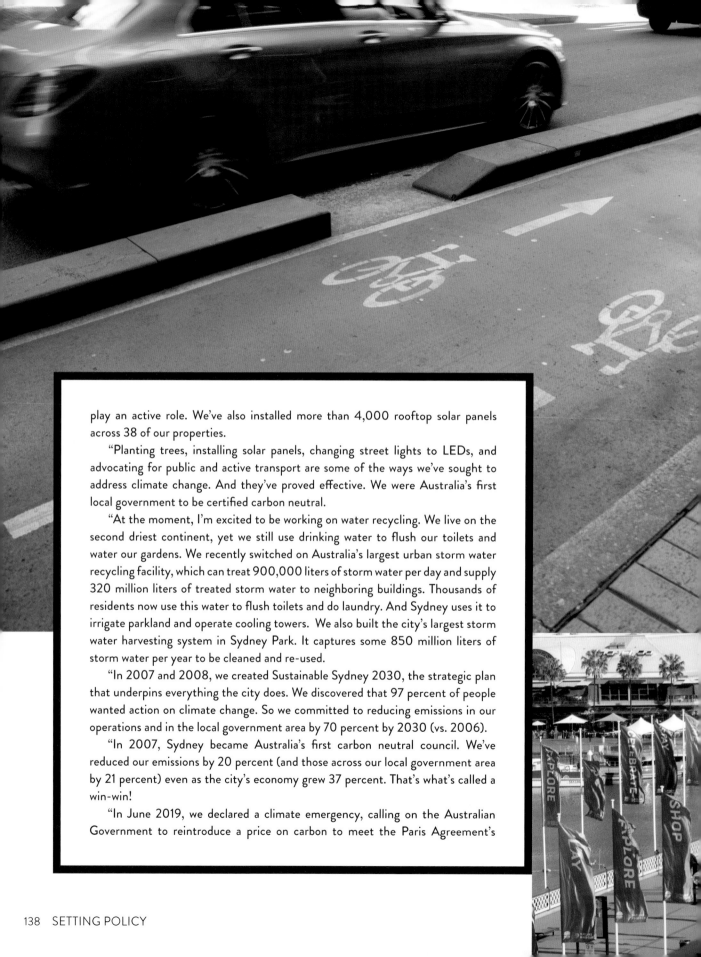

play an active role. We've also installed more than 4,000 rooftop solar panels across 38 of our properties.

"Planting trees, installing solar panels, changing street lights to LEDs, and advocating for public and active transport are some of the ways we've sought to address climate change. And they've proved effective. We were Australia's first local government to be certified carbon neutral.

"At the moment, I'm excited to be working on water recycling. We live on the second driest continent, yet we still use drinking water to flush our toilets and water our gardens. We recently switched on Australia's largest urban storm water recycling facility, which can treat 900,000 liters of storm water per day and supply 320 million liters of treated storm water to neighboring buildings. Thousands of residents now use this water to flush toilets and do laundry. And Sydney uses it to irrigate parkland and operate cooling towers. We also built the city's largest storm water harvesting system in Sydney Park. It captures some 850 million liters of storm water per year to be cleaned and re-used.

"In 2007 and 2008, we created Sustainable Sydney 2030, the strategic plan that underpins everything the city does. We discovered that 97 percent of people wanted action on climate change. So we committed to reducing emissions in our operations and in the local government area by 70 percent by 2030 (vs. 2006).

"In 2007, Sydney became Australia's first carbon neutral council. We've reduced our emissions by 20 percent (and those across our local government area by 21 percent) even as the city's economy grew 37 percent. That's what's called a win-win!

"In June 2019, we declared a climate emergency, calling on the Australian Government to reintroduce a price on carbon to meet the Paris Agreement's

"The City of Sydney belongs to C40 Cities, a group of city governments around the world that share knowledge and act together to address climate change."

"We're not waiting. Seventy percent of global emissions are generated by cities, so city governments' actions are critical."

targets, and to establish a Just Transition Authority to ensure Australians employed in fossil fuel industries find alternate employment.

"But we're not waiting. Seventy percent of global emissions are generated by cities, so city governments' actions are critical. A big part of Sydney's appeal is the climate, the ability to be outdoors in a pristine natural environment, with fresh air, clean water, and walkable streets, all of which are threatened by climate change.

"The tourist industry represents 21 percent of the city's greenhouse gas emissions, and our hotels are typically twice as energy and water intensive as office buildings in impact per square meter. So we're pleased that our leading hotels, event centers, cultural institutions, and tourism bodies are working with us to improve their environmental performance through a new Sustainable Destination Partnership. One partner, the Sydney Opera House, has announced that it will be carbon neutral five years ahead of schedule.

"What's more, our new operating budget will enable us to implement programs that encourage more solar and large-scale renewable projects.

"We also emphasize recycling. For example, sandstone excavated to build a new Metro line will form the foundations of an airport runway in Western Sydney.

"The City of Sydney belongs to C40 Cities, a group of city governments around the world that share knowledge and act together to address climate change. The science is clear. Without urgent, co-coordinated, global action, we face a high risk of runaway climate change."

Runaway climate change. Clover Moore, the girl who gave her parents trees as birthday gifts, now shows the world's cities how to prevent it.

WHAT YOU CAN DO

1. "Never, ever, stop demanding more from your elected representatives. If we're going to stop runaway climate change, we need big, structural change—and that is the role of government," Lord Mayor Moore observes.

2. "Love and protect your local park," she advises.

3. Use LED light bulbs. They use 85% less energy and last 25 years.

ACTION

"Each month we fail t

worth o

GOING GLOBAL

What strikes you immediately about EARTHDAY.org is the scale.

Think billions. EARTHDAY.org celebrated its 50th anniversary by planting 7.8 billion trees—one for every person on Earth. Fortunately, EARTHDAY.org had help, thanks to affiliations with partner organizations in 192 countries.

In addition to tree planting, EARTHDAY.org is working with the Wilson Center and US State Department to coordinate "Earth Challenge," the largest citizen science initiative ever. Planners aim to identify a billion data points collected by citizen scientists around the world.

Wisconsin Senator Gaylord Nelson, a Democrat, came up with the idea for a national Earth Day in 1969, and persuaded California Representative Pete McCloskey, a Republican, to be his co-chairman. More than 20 million people took to the streets on the first Earth Day in April, 1970, the largest civic engagement event in human history.

Kathleen Rogers, EARTHDAY.org's president since 2001, joined the organization because she was keenly interested in "going global"—tackling environmental issues around the world as well as in the US.

She's proud to report, "I actually changed the mission statement of the organization to 'diversifying, educating and activating the environmental movement worldwide.'"

To act on her words, Kathleen forged affiliations with "African American and Latino groups in the US, the Vatican, the Sikhs, the Buddhists, the Red Cross, the Boy and Girl Scouts, faith groups, local elected officials, farmers, non-environmental groups, women's groups, you name it."

And she created a special program for women. EARTHDAY.org started a global campaign called Women and the Green Economy (WAGE) to bring women leaders together to begin a conversation.

"I would go to climate conferences and see only a handful of women. To solve the climate crises, we need to bring women into the conversation and look for equal

ct, we create a year's damage."

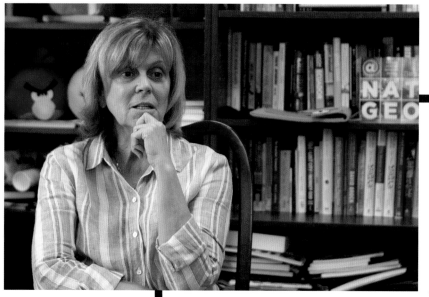

representation at the table. That includes boardrooms, national governments, global institutions, NGOs, local elected officials, school boards, and other sectors of our society. Women are strategic long-term thinkers and we need both short-and-long term solutions to solve our climate crisis. And we need women making decisions about how we're going to develop a green economy."

Despite its name, EARTHDAY.org no longer focuses on just one day. "We work all day every day," said Kathleen. "Climate is the overarching issue, but we also focus on related issues, such as food production and plant-based diets, plastics, biodiversity loss, climate and environmental literacy, green technology, and reforestation. All are central to solving climate crises.

"Once a keystone species goes, others start to. When you remove forests or use grasslands to produce food, the decline accelerates. Some scientists say we could see as many as half of the world's species become extinct in two decades. To make that more real, think of the pollinators

"We need to bring women into the conversation and look for equal representation at the table."

at risk. We can't live without them. Yet we douse them with insecticides, clear cut their habitats, force them to pollinate monocultures, and create other conditions that undermine their health.

"I'm part scientist, part lawyer, part activist. I have worked on environmental issues for more than 25 years, but even I can't believe some of the recent reports I read. Every year we wait to act, the more difficult it will be to restore the planet. Iceland, Greenland, and the Arctic are melting fast. Each year it accelerates, it snowballs, and the result is that each month we fail to act, we create a year's worth of damage."

WHAT YOU CAN DO

1. "Vote for candidates who have ambitious, convincing plans to protect our planet. The League of Conservation Voters and many states publish scorecards that summarize candidates' positions," says Kathleen.

2. "Recruit five people to act with you. Sign petitions, do cleanups, participate in town hall meetings, demand that governments and corporations do right by the environment. Together we can create a movement."

3. "Join EARTHDAY.org's Earth Challenge, which invites kids and adults to collect information about biodiversity, pollution, air, water and human health. Everyone uses a standard method, and all the information goes into one database, for use by scientists everywhere. Find out more on the Our Work page of EARTHDAY.org."

4. "Practice what you preach. Once you get going it isn't that hard. And don't feel guilty. Governments and corporations bear most of the responsibility. That's where voting comes into play."

5. "Knowledge is power. A good place to learn about climate change is on the website of EARTHDAY.org, which is full of information, including ways to become involved."

6. "Help offset deforestation by donating to EARTHDAY.org's Canopy Project. 1 USD = 1 tree. A single tree absorbs a ton of carbon dioxide during its lifetime."

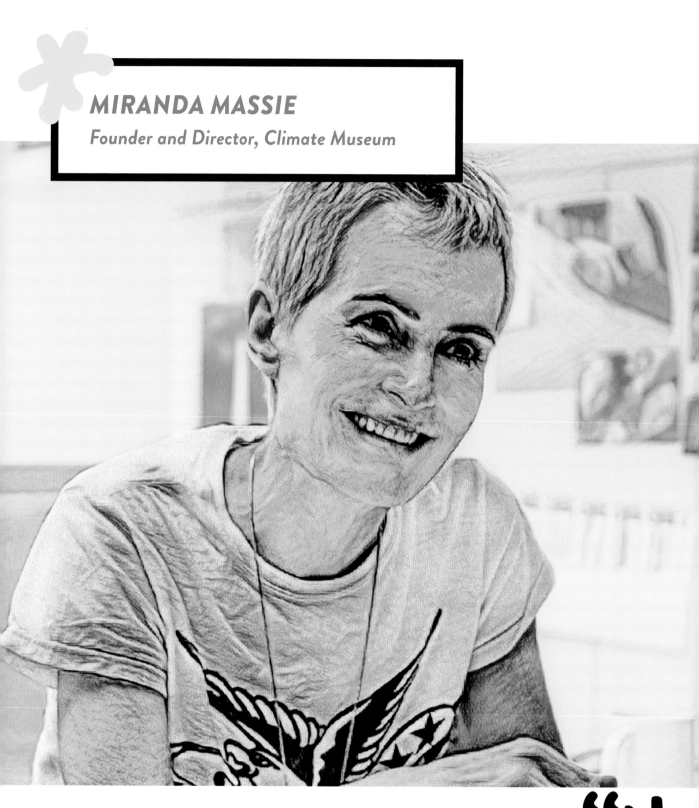

"No

EARTHLING TRIES TO EXPLAIN GLOBAL WARMING TO A MARTIAN

Miranda Massie plants her elbows on her desk and pretends she's talking to a "good-natured Martian who doesn't understand our psychology, culture or politics. I would never be able to explain to her why we are not taking action on the thing that most threatens everything that's most precious to us, from the future dreams of our children, to the health of world populations, to every wilderness on the planet."

She shakes her head, "Our genius, inventiveness, ambition, and creativity caused this climate crisis that could obliterate civilization as we know it. It's the greatest challenge the human species has ever encountered."

Miranda founded and directs the first and only Climate Museum in the United States. "Museums have a huge transformative power that comes from the trust the public has in them, plus their popularity. Guess how many museum visits there are in the US in every year: 850 million! Take major league sports, add on the top 20 amusement parks, then add on national park visits, and you're still not at 850 million!

"Going to a museum is inherently social, collective learning. That builds a sense of community. With climate in particular, which can be scary and unnerving, arts offer a very soft pathway into feeling like you're not being forced to take a position, you're just being invited to be in your own experience."

Miranda remembers, "My climate crisis unease came to a head in Super Storm Sandy. There was a kind of tectonic plate shift in my psychology. The idea for a climate museum popped into my head and I was like, 'I'm going to figure

Icebergs Ahead."

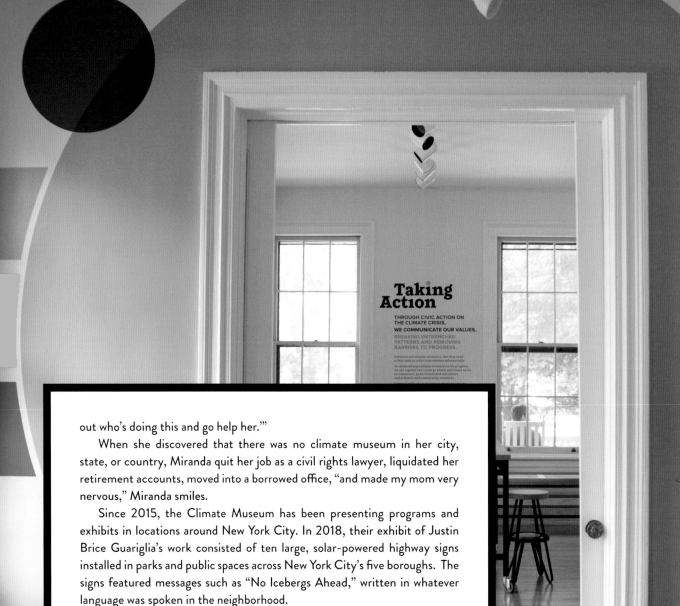

out who's doing this and go help her.'"

When she discovered that there was no climate museum in her city, state, or country, Miranda quit her job as a civil rights lawyer, liquidated her retirement accounts, moved into a borrowed office, "and made my mom very nervous," Miranda smiles.

Since 2015, the Climate Museum has been presenting programs and exhibits in locations around New York City. In 2018, their exhibit of Justin Brice Guariglia's work consisted of ten large, solar-powered highway signs installed in parks and public spaces across New York City's five boroughs. The signs featured messages such as "No Icebergs Ahead," written in whatever language was spoken in the neighborhood.

"We started exhibiting on Governors Island in 2018, and now have an agreement to present six-month exhibits over three years," Miranda tells us.

Avery, her Dad, and I hop on the ferry to Governors Island the very next day. The boat swings away from the dock and we glimpse the Statue of Liberty. Soon, the brick buildings on the island appear; we pull up to Yankee Pier, then stroll into Nolan Park, where Victorian houses ring the grassy, shady oval. Two teen volunteers sit in rocking chairs on the porch of House Number 18, and invite passersby into the Climate Museum's Take Action exhibit.

Young people are so important to climate action that it's hard to imagine anyone else leading our tour. The exhibit begins with a display of fruits and vegetables, each weighted to represent its carbon footprint. Next: a collection of magnetic wind chimes. Then solar-powered bugs.

Every part of the exhibit is interactive. There are iPads with questionnaires,

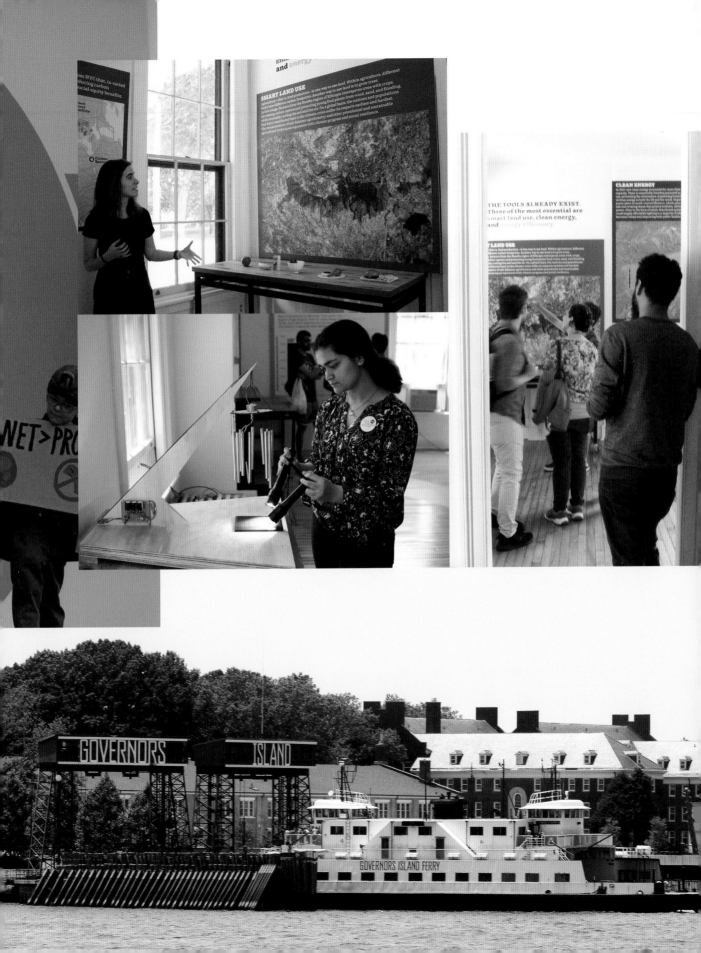

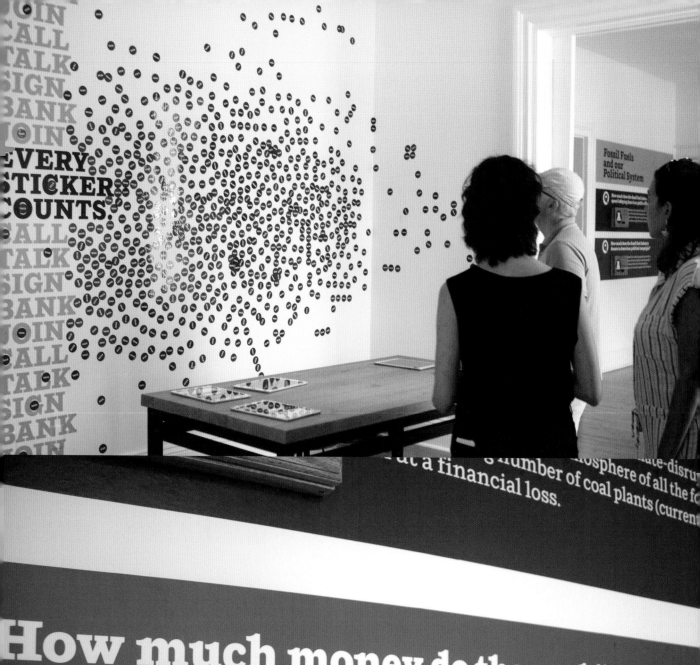

EVERY
STICKER
COUNTS.

COIN
CALL
TALK
SIGN
BANK
JOIN
CALL
TALK
SIGN
BANK
JOIN
CALL
TALK
SIGN
BANK
JOIN

Fossil Fuels
and our
Political System

...at a financial loss. ...number of coal plants (curren... ...osphere of all the fo...

How much money do the world's large
banks spend financing the fossil fuel ind

...y availability of capital from large b...
the continuing growth of the fossil fuel indu...
a significant barrier to climate progress.
Consumers can register their views on thes...
direct advocacy and by switching to a climat...

Since the Paris Agreement
was signed in December 2015,
$1,900,000,000,000.
This represents more
currency than is

SMART LAND USE

Smart land use includes better agricultural practices, conservation of existing forests, planting new trees, and other positive changes in land use that lead to lower emissions.

CLEAN ENERGY

Clean energy includes solar, wind, and geothermal energy as well as newer technologies like tidal and wave energy. Note that some, but very little, new nuclear power is included in the calculations represented here. See more in the info sheet on the station table.

EN
EF

Energ
captu
broad
includ
refrige
and al
ride sl
from c
bikes.
gains
in this
gover
and ef

THE CLIMATE MUSEUM

WE ARE Taking Action ON THE CLIMATE CRISIS IN THIS

> "There was a kind of tectonic plate shift in my psychology."

space for people to pin comments, and stickers to paste on a wall to confirm the steps visitors plan to take. People lean against the tables and discuss their feelings, questions, opinions, and choices.

Miranda reflects, "People are so hungry for a space where they can talk to other people about climate, think about it, and have their full range of feelings about it. The response of the public to what we've done has been more confirming than I would have ever dared imagine.

"As a culture, we are socialized to think about big questions in terms of personal responsibility and guilt. Guilt and moralism are no way to move forward on the climate crisis. We are all completely embedded in this fossil fuel economy.

"The climate museum's emphasis is on building climate citizenship—a public culture that focuses on climate and puts the climate crisis at the center of our collective decision making. That's where it belongs.

"Once you start the flywheel—and if you believe your actions are going to be joined by those of others, and that they will then inspire yet more people to take action—then you build a virtuous cycle that will continue to move itself forward," Miranda nods.

Surely even her invisible Martian would understand and applaud that!

WHAT YOU CAN DO

1. "Declare yourself. Tell your elected representatives that you're a climate voter," Miranda says. "Hold them accountable for climate-relevant decisions such as whether they accept funding from the fossil fuel industry and are pursuing aggressive legislation and policies to create climate progress."

2. "Talk to your friends and family about the climate crisis. Recognize that we all have a tendency to turn away from this emergency because it's very unnerving and hard to cope with. Bring people into the conversation in a way that destigmatizes the subject and makes discussion safe."

3. "Join a climate-focused organization. One thing that makes people turn away is the feeling that, as individuals, we cannot affect the climate crisis. That's correct. One call to a congressperson won't do it; one hundred will."

4. "Divest fossil fuel stocks from your portfolio and demand that your bank and pension fund do the same. One reason for the climate crisis is that fossil fuels have a ready flow of capital."

5. "Vote your proxies for executives who champion programs that combat global warming."

"Discourse

SOS: SAVE OUR SPECIES

Psychoanalyst Margaret Klein Salamon doesn't mince words. "Global warming is an existential crisis. We are all in danger. I want us all to take on solving our climate crisis as our personal mission. And I don't think we have a choice.

"We are committing collective suicide. If we're to have a chance of protecting humanity and the natural world, we need to wake up. Only when we understand this and feel it emotionally, will we accept the kind of changes we need to make."

When Dr. Salamon witnessed the devastation that Hurricanes Irene and Sandy inflicted on her community, her first idea was to start a blog, The Climate Shrink, but a friend challenged her, "Discourse is not enough. What could you do to actually solve this problem?"

"That challenge is the before and after in my life, which is forever changed.

"I researched what is actually happening to our climate and why are we in such denial. And then I launched The Climate Mobilization, a grassroots advocacy group working for large-scale political action against global warming, based on the conviction that what's required is a national economic effort.

"The Climate Mobilization supports an immediate ban on all new fossil fuel infrastructures, an immediate ban on single-use plastics, an immediate ban on all new fossil fuel-powered vehicles, a five-year transition to all-organic agriculture and more.

"The communications paradigm of the climate emergency movement is to tell the truth. We don't need to fear people's feelings. Fear, grief, and despair are rational responses to living during the mass extinction of species. What we need to do is harness those feelings and turn them into political power for transformative change."

Dr. Salamon started The Climate Mobilization in 2014. Two years later, its language and goal were embedded in the Democratic Party Platform: "We need a World War II-scale climate mobilization."

"In 2018, Extinction Rebellion, the Green New Deal, the School Strikers, and

s not enough."

The Climate Mobilization aligned around their idea," Margaret says.

Co-author Avery points out that she wasn't alive during World War II and asks what, specifically, Margaret means.

The doctor responds, "At first when Germany and Japan started invading other countries, Americans were in denial: 'It's not our war,' they said. But Japan's attack on our Pearl Harbor naval base in Hawaii ended that; Congress declared war; and we saw all-out mobilization.

"President Roosevelt ordered the auto companies to start manufacturing planes and tanks. Your great grandparents and most of their neighbors grew their own vegetables in victory gardens. Millions of men and women joined the military.

"There were scientific breakthroughs in every field: the first blood transfusion, the first computer; radar and sonar were developed.

"This is what can happen when you mobilize, which is why we named our organization The Climate Mobilization."

Margaret acknowledges that while individual behavior changes are important, "We must have political solutions. The Climate Mobilization supports elected champions. We call for the United States' top foreign policy priority to be zero emissions globally. Everything should be based around that: how we give aid, what our military is doing, everything."

I ask, "Without another Pearl Harbor, how can we persuade people to urge political action against climate change?"

Margaret responds, "We need a social movement with a vision that feels real and doable, that people can join. If the government is not fully on board, it just means the movement needs to be stronger. When people come together in a social movement, they're much more powerful than the governments. We just aren't currently exercising that power.

"I'd like to see every local, state and national government declare a Climate Emergency. It is a crucial first step that sets the stage for a broad mobilization that can save civilization."

As of February 2022, some 2075 Climate Emergencies had been declared around the world.

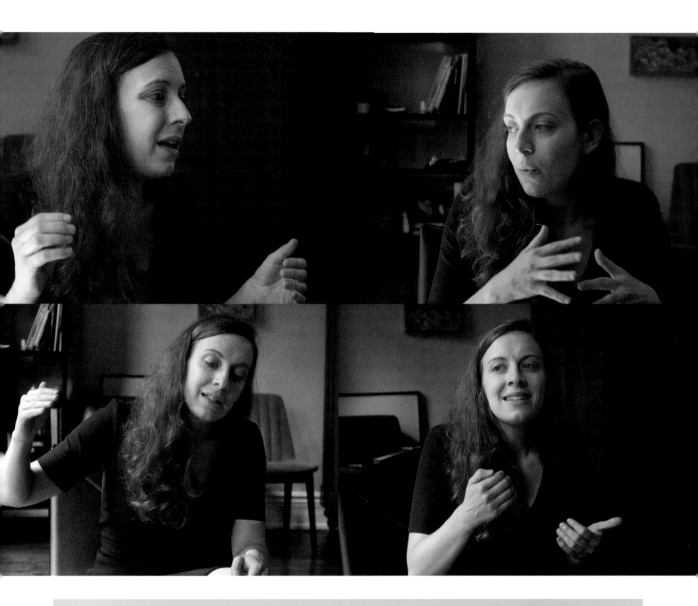

WHAT YOU CAN DO

1. Declare a Climate Emergency in your hometown. Everything you need is at theclimatemobilization.org (click on the tab "The Emergency").

2. Call on the US Government to conduct a World War II-scale mobilization and end all greenhouse gas emissions in less than a decade.

3. Start or join a local Climate Mobilization group (go to theclimatemobilization.org and click on "Join Us").

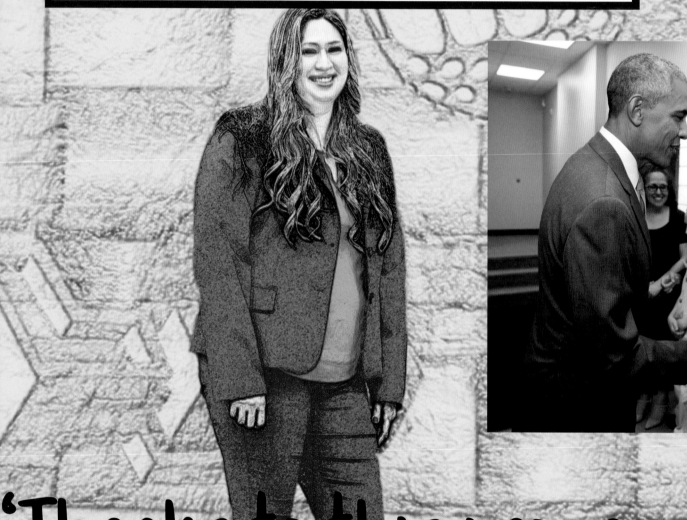

'Thanks to this program
the privilege of lifting

LAS MADRES Y LOS POLITICOS

Ask a Latina mother what she wants to talk with her elected representatives about, and you'll get a two-word answer: global warming. Ask why, and you'll get another two-word answer: my kids.

EcoMadres will help her. It's a program that connects mothers and elected officials, and the focus is on their children. Gabriela Rivera, who oversees EcoMadres' field organizers across the United States, explains: "Many Latinos reside in communities that suffer the impacts of air pollution and climate change disproportionately. And their children have asthma as result. They often miss school and have to go to the doctor. Their parents have to miss work to take care of them, which complicates family life and sometimes puts pay-checks at risk."

For EcoMadres, issues of immigration and climate change are linked. Gabriela points out, "You hear on the news that families coming to the US are fleeing corruption and violence. But you don't often hear that they're also coming because of climate change. Flooding. Heat. Drought. Their crops dying. Food is unavailable. Those things are equally important."

EcoMadres came into being when Moms Clean Air Force and Green Latinos formed a partnership. It has expanded to include a broad cross-section of Latino organizations, and it plans to reach further into more communities where Latinos live and work. EcoMadres educates, engages, and empowers members to have conversations with their lawmakers about the environment's effects on their children's health.

Once they learn how to tell their personal stories and feel comfortable enough, they meet with their members of Congress and their states' legislators, and talk about issues that impact them personally. They may also bring their children. When there are hearings in Washington, DC, EcoMadres

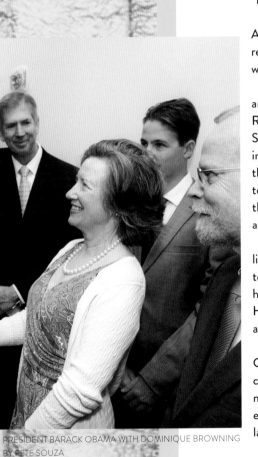

PRESIDENT BARACK OBAMA WITH DOMINIQUE BROWNING
BY PETE SOUZA

we have the voices of so many."

GABRIELA RIVERA & DOMINIQUE BROWNING 161

often mobilizes its members to attend so they can provide face-to-face testimony.

EcoMadres also supplies members with "naptime note cards" so mothers can write to their representatives while their kids are sleeping.

"We hand deliver naptime notes to senators and representatives," says Gabriela, "and we explain that the cards enable them to hear from constituents who aren't able to come to their offices."

The best way to learn about EcoMadres—and get naptime note cards—is to participate in a Cafecito. Volunteers lead get-togethers in community centers, churches, living rooms—places that lend themselves to informal conversations.

Cafecitos are the soul of EcoMadres. They take place every few weeks and focus on environmental issues that impact children's health and how to advocate for policies that protect them.

EcoMadres has chapters in a dozen states with more to come, and you can attend a Cafecito in any of them. Chances are, you'll also be able to feast on pan dulce, a Mexican pastry, or perhaps a pambazo (a Mexican bread filled with potato and chorizo, then dipped in pepper sauce and fried). Is your mouth watering?

Gabriela Rivera was born in Chihuahua, Mexico. She explains, "My parents instilled in me the ideas of hard work and motivation, and the need to make this world a better place for all."

After earning a Master's degree in Public Affairs from the University of San Francisco, and working as a political organizer, Gabriela led the creation of EcoMadres.

"Thanks to this program, we have the privilege of lifting the voices of

"Latinos reside in communities that suffer the impacts of air pollution and climate change disproportionately."

GABRIELA RIVERA & DOMINIQUE BROWNING 163

> "EcoMadres also supplies members with 'naptime note cards' so mothers can write to their representatives while their kids are sleeping."

so many and inspiring people across the country.

"I'm often asked about our name, which I love. It's three words in one. 'Eco' represents the environment. 'Madres' represents mothers. And 'comadres' are a co-parent or godmother in the Latino community. So when you say, 'She is my comadre,' you're creating a family where you don't have to be blood-related, you just have to care about the same issues and be willing to advocate for the same reasons."

If you'd like to become an EcoMadre, you can sign up at the Moms Clean Air Force's website. And your kids can become EcoNiños.

MOTHERHOOD FIRST

"Being a mom not only comes first for me, it informs my political activism," says Dominique Browning, mother of two sons, grandmother of one, writer, and accomplished political organizer.

Dominique co-founded Moms Clean Air Force in 2011 to explain climate change to mothers and other non-scientists so they could engage government officials and change laws.

Today, Dominique is senior director of an organization of a million plus moms (and dads) across the United States that works to ensure that laws that protect children's health and well-being are as strong as they can be.

I invite Dominique to share the ways her members—and the rest of us—can be most effective influencing elected officials about climate change.

She smiles: "I have a vivid image because this happens so often when we go with mothers to visit the Senate. They pause outside the building and ask, 'Are you sure it's okay to be here? Are we allowed to walk these halls?' It reminds me that our political processes are so far from our daily experiences that we've lost touch with them.

"The first time moms visit elected officials, the most important thing we do is help them cross the threshold into political engagement. Whether it's visiting members of Congress or their staffers, or calling on local and state elected officials, we invite them to cross that threshold and make the visit. We point out that elected officials want to hear from them, and that it makes a big difference when you contact the people who represent you.

"The second thing is, we make sure our members are educated on the issues, so they can respond to pushback.

"We also urge people to tell their own stories about losing their houses, crops, animals, or health. This is especially true for women who come from areas that have been ravaged by floods, wildfires, or any of the other ways climate change is super-charging destructive weather events.

"Meetings are the most effective way to communicate with elected officials, especially meetings with staff members. People forget (or don't know) how

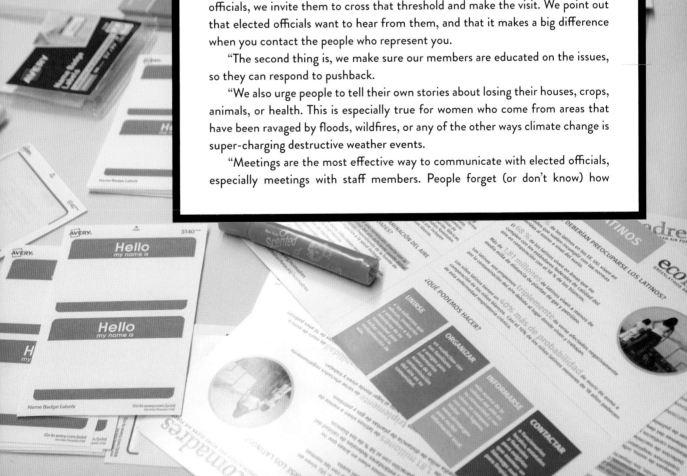

important staff members are. Sometimes it's better to meet them in district offices, rather than Washington, DC. They usually report to the Washington office daily. And you can have a more intimate connection.

"Handwriting personal letters can also be important. The bottom line is that the more personal the touch, the more important the touch.

"Reach out to your city's mayor and its legislators. For example, if you live in Houston and your mayor wants to develop a climate plan, volunteer to help; say, 'Way to go; we need that.'

"We've also gotten deeply involved with the Environmental Protection Agency. Often things can be done through regulation rather than legislation, so we visit EPA people at every level.

"You could spend all day influencing people. It's useful to contact your local Walmart and say, 'Saw the solar panels on your roof; give us more!' Or your local utility and say, 'Make my energy mix renewable.'

"We coordinate campaigns via our website (MomsCleanAirForce.org), so our members can communicate at the same time about national legislation that's happening, regulations that are pertinent, or events such as Earth Day.

"Climate impacts tend to be local, so local Moms Clean Air Force organizers generate discussions and convene meetings that might happen around a dinner table, over a cup of coffee, or at a school. Sometimes local organizers bring in speakers, perhaps a pediatrician, to talk about the health impacts of extreme weather and its connection to climate change.

"Our goal is to explain to people how many different avenues there are for change, and to simplify the process so they understand what to talk about."

WHAT YOU CAN DO

1. Talk with your kids and grandkids about the climate they'll live with in the future, and what you can do together to improve it.

2. Vote.

3. Speak out. Speak up. Smile. Politicians work for you. Meet with national, state, and local elected officials. "When we engage with mayors," Gabriela says, "they listen. When EcoMadres walk the halls of Congress (or district office halls), staffers welcome us. 'The Moms are coming!'"

4. Demand wind and/or solar from your local power company.

5. Buy a car that gets high gas mileage, is a hybrid, or electric. And drive it prudently. Speeding increases pollution from tailpipes.

"We are the sentinels
We live at the

INDIGENOUS WISDOM, THE MEDICINE WE SEEK

You're about to meet the:

* Past-president of the Inuit Circumpolar Council Canada for two terms
* Past-chair of ICC International, which promotes Inuit interests in Russia, Alaska, Canada, and Greenland
* Leader of the world's first international legal action on climate change: a petition co-signed by fellow Inuit from Canada and Alaska
* Author of a groundbreaking memoir that reframed climate change as a human rights issue, *The Right to Be Cold.*
* Recipient of awards that cover three Wikipedia pages
* Featured advocate on a Canadian postage stamp

Sheila Watt-Cloutier has invested three decades to advocating on her people's behalf. And their lives have changed for the better as a result. But the challenges persist, and they are formidable.

Climate change is causing the Arctic to warm twice as fast as the rest of the planet. The permafrost is melting, so buildings buckle in Sheila's homeland; houses sink; runways crack; coastal banks are eroding. Snowmobiles have fallen through the thinning ice.

The impacts are not merely physical, they are cultural. Hunting is one of the Inuit culture's cornerstones but the animals and marine mammals that the Inuit hunt for food and clothing are struggling.

"The world I was born into has changed forever. Snow and ice represent mobility," says Sheila, who grew up traveling by dogsled. "When mobility starts to go, everything becomes precarious.

"We are the sentinels. We live at the top of the world, so we're the first to witness the changes that are happening to our planet. The Arctic is its barometer. Everyone benefits from a frozen Arctic, but for us, it's our birthright.

SHEILA WATT-CLOUTIER ILLUSTRATION BASED ON PHOTO BY ISABELLE DUBOIS

top of the world."

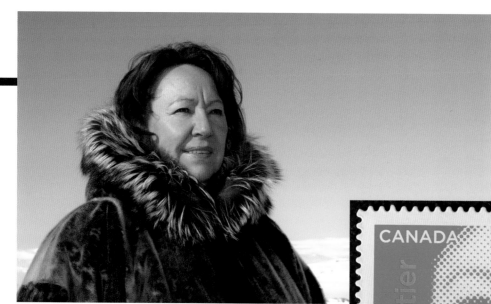

SHEILA WATT-CLOUTIER, PHOTO BY STEPHEN LOWE

"We Inuit learn holistically to assess situations by evaluating weather patterns, clouds, ice, wind. Waiting for snow to fall teaches patience. From hunting, we learn how to be bold and courageous, how to be proficient at taking care of our families, how to develop sound judgment and wisdom. We learn tenacity and focus.

"We are scientists in our own right. We know about animals, migrations, the land, and the changes that are happening. Western scientists say they've learned from our hunters. The marriage of their science and our traditional knowledge has been groundbreaking. Indigenous wisdom is the medicine we seek to create a sustainable world.

"I was raised by my mother and grandmother and taught how our elders approach things: calm and reflective. I've never wavered from this approach. If you're going to bridge gaps and build partnerships, you need to bring people in, use the power of influence, not the power of conflict.

"I've put my faith in people's innate concern for others. If I can appeal to their hearts and use solid facts to back up my story, I may be able to change their attitudes. The only way I know to do this is to speak from my heart."

"We Inuit learn holistically to assess situations by evaluating weather patterns, clouds, ice, wind."

Inuit people believe everything in the world is inter-related, inter-connected and inter-dependent. In her book Sheila writes, "Our shared atmosphere and oceans, not to mention our human spirit, connect us all. It's important that climate change is not framed as just an economic, scientific or political issue. It's a human issue.

"So I urge people to move from their heads to their hearts, where all change happens, and to know that change provides an opportunity to flourish in the future, to create a better world.

"But we need to act. Mother Earth is a living, breathing entity. When you're out in nature, you can sense that she's reaching her limits."

WHAT YOU CAN DO

1. "Listen to—and learn from—the world's indigenous people, and make sure our voices are heard at local, regional, national, and international levels. Be sure we are supported to take part in the global process," says Sheila.

2. "Learn from COVID-19. It has given us a chance to pause and think about the connection between viruses, environmental degradation, and climate change. People blame bats for the virus, but actually it is industry that has affected the wildlife. We owe it to ourselves to take a hard look at what we're doing to this planet of ours."

3. "Learn more about the human dimension of climate change. Indigenous knowledge, including a respect for the environment, as well as empathy and respect for one another, should be taught in elementary schools, secondary schools, and universities."

4. "Bring back the heartbeat of life, the spiritual way in which we can live and work together. We can't overestimate the power of art, performance, story, and ceremony to bring purpose and pride. If we can stop 'othering' each other and, instead, relate through soul, spirit, and understanding, we can create a better world."

AVERY SANGSTER
Co-author

By age 10, I knew global warming was a pressing issue. But it wasn't until I saw the wildfires burning our city and forcing thousands of people to leave their homes that I knew I had to act.

I began talking with my grandmother about writing this book.

My friends and I created a website to inform other kids about the dangers of global warming—and what we can do right now to reverse it.

Actions like ours produce ripple effects that spread through our families, our friends, and our communities.

It's a fact. If all of us do a few small things, we make a big impact. There are levels of involvement for every single one of us. By simply turning off the lights when we leave a room, reusing household items, or buying locally, we lessen our carbon footprint. Walking to places nearby instead of driving not only reduces emissions, but also provides us with fresh air and exercise.

I'm 68 years younger than my co-author, which means I'll be as old as she is today in 2088…if you and I and our fellow earthlings are able to keep our planet—and ourselves—from burning up.

I intend to do all I can to keep that from happening, and I hope you will too.

WHAT ELSE YOU CAN DO

POLITICAL ACTIONS

1. Support local, state, and national government initiatives that retrain people whose jobs are eliminated by programs that limit greenhouse gases—even if your tax bills go up.

2. Advocate public funding of election campaigns, which will prevent special interests from thwarting efforts to reverse global warming.

3. Support elected officials who advocate increasing investment in clean energy research.

4. Demand that your elected representatives put a price on carbon.

5. Organize and mobilize a group for action: your school, company, church, team.

6. Sign the Women Lead Climate petition at WomenLeadClimate.org. It urges support for women's climate leadership and for programs that directly affect women, girls, and climate justice.

7. Champion farmers who practice carbon farming, which sequesters carbon dioxide, restores (vs. exhausts) the soil, and makes it more fertile.

PERSONAL DIAGNOSTICS

Check out these websites and related resources:

- The US Environmental Protection Agency Carbon Footprint calculator (www3.epa.gov/carbon-footprint-calculator)

- The Nature Conservancy Carbon Calculator (www.nature.org/en-us/get-involved/how-to-help/carbon-footprint-calculator/)

- The US Department of Energy Appliance Energy Calculator (www.energy.gov)

- Stand.earth challenges corporations and governments to treat people and the environment with respect. (www.stand.earth)

- Mothers of Invention is a podcast on feminist climate change solutions from (mostly) women around the world. (www.MothersOfInvention.online)

- Good on You is a sustainability ratings platform for fashion. (GoodOnYou.eco)

FINANCIAL ACTIONS

1. Include organizations that combat global warming in your estate plan.

2. Invest in exchange traded funds that focus on reducing carbon emissions.

3. Increase your financial portfolio's stake in clean energy companies.

4. Make sure your workplace, pension fund, or university does not invest in fossil fuels. If they do, join or start a divestment campaign.

5. Support organizations that raise climate change issues via shareholder proxies at corporation's annual meetings. (Two examples: Ceres.org and AsYouSow.org)

ACTIONS AT HOME

1. Get an energy audit of your house.

2. Use less heat and air conditioning.

3. Add insulation to your walls and attic.

4. Install weather stripping and caulking around doors and windows.

5. Turn down the heat when you're away and when you're asleep.

6. Purchase only FSC (Forest Stewardship Council) products like toilet tissue and paper towels. Or use tea towels instead of paper towels.

7. Use less hot water. Set your water heater at 120 degrees. Take shorter cooler showers (the UN suggests 5 minutes). Buy low flow showerheads.

9. Wash clothes in cold or warm water.

10. Turn off the lights when you leave the room.

11. Hang dry clothes instead of using the dryer.

12. Install a heat pump in your home to transfer heat from one location to another.

13. Store food in reusable containers instead of paper or plastic bags.

14. Take advantage of an app called TRANSIT that aggregates bus, train, bike-share, and other alternatives to show you transportation options. (transitapp.com)

RESOURCES

Introduction

Figueres, Christiana and Tom Rivett-Carnac. *The Future We Choose: Surviving the Climate Crisis.* (New York: Alfred A. Knopf, 2020).

FP Analytics. *"Women as Levers of Change: Unleashing the Power of Women to Transform Male-Dominated Industries."* (Washington, DC: FP Group, 2020) WomenAsLeversOfChange.com

Hawken, Paul (ed.). *Drawdown: The Most Comprehensive Plan Ever Proposed to Reverse Global Warming.* (New York: Penguin Books, 2017).

Jahren, Hope. *The Story of More: How We Got To Climate Change and Where to Go from Here.* (New York: Vintage Books, 2020).

Kim McKay, Director/CEO, Australian Museum

Australian Museum: australianmuseum.net.au

Barlass, Tim, "Drought and Bushfires Stopping Frogs from Mating." *Sydney Morning Herald.* November 28, 2019.

Kahn, Jo. "Australia's Frogs, Reptiles, and Invertebrates Are at Risk of Extinction from Bushfires, Too." *ABC News.* January 7, 2020.

McKay, Kim, Lynley Crosswell, Brian Oldman, Alec Coles, Jim Thompson, and Marcus Schutenko. "Statement from Australia's Natural History Museum Directors." *australianmuseum.net.au.* February 3, 2020.

Power, Julie. "Going for Croak: Under Threat, Frogs Hitchhiking Their Way Back to Life." *Sydney Morning Herald.* May 1, 2019.

Rowley, Jodi. "Silent Nights: Frogs, Drought and Fire." *Australian Museum Blog.* January, 21, 2020.

Leonie Wechsler and Anna Zaske, students, Copenhagen International School

Copenhagen International School: www.cis.dk

Sengupta, Somini. "Copenhagen Wants to Show How Cities Can Fight Climate Change." *New York Times.* March 25, 2019.

Girl Leaders Around the World

Fridays for Future: www.fridaysforfuture.org

Alter, Charlotte, Suyin Haynes and Justin Worland. "2019 Person of the Year: Greta Thunberg." *Time Magazine.* December 11, 2019.

Bengal, Rebecca. "The Seas are Rising—And So are They." *Vogue Magazine.* October 4, 2019.

Kann, Drew. "Greta Thunberg and 15 Other Children Filed a Complaint Against Five Countries over the Climate Crisis." *CNN.* September 23, 2019.

Kaplan, Sarah. "How a 7th-Grader's Strike Against Climate Change Exploded into a Movement." *The Washington Post.* February 16, 2019.

Kormann, Carolyn. "New York's Original Teen-Age Climate Striker Welcomes a Global Movement." *The New Yorker.* September 20, 2019.

Neubauer, Luisa. "Why You Should Be a Climate Activist." *Tedxyouth@München.* September 6, 2019.

Thunberg, Greta. *No One Is Too Small to Make a Difference.* (London: Penguin, 2019).

Stella Adelman, Managing Director, Dance Mission Theater and Krissy Keefer, Artistic Director, Dance Brigade and Dance Mission Theater

Dance Mission Theater: dancemissiontheater.org

Aguilar, Rose. "One Planet: March 15th International Day of Youth Climate Strikes." *Your Call: KALW.* March 11, 2019.

Dance Mission Theater. *D.I.R.T. (Dance in Revolt(ing) Times Festival 2019: stormSURGE: The Waters are Rising.* San Francisco, March 9–17, 2019.

Molly Burhans, PhD, Founder and Executive Director, GoodLands

GoodLands: good-lands.org

Young Champions of the Earth: unep.org/youngchampions

O'Loughlin, Michael J. "Can High-tech Maps Help the Church and Save the Planet?" *America: The Jesuit Review.* January 11, 2019.

Stumpf, Simon with Molly Burhans. "Can This Lay Woman Transform the Way the Catholic Church Manages Its Land?" *Forbes.* October 18, 2018.

Wangsness, Lisa. "This Woman Is Trying to Map the Global Catholic Church." *Boston Globe.* August 2, 2017.

White, Christopher. "UN Honors Catholic Activist Using Data to Fight Climate Change." *Crux Now.* October 8, 2019.

Nelleke van der Puil, PhD, Vice President of Materials, LEGO

LEGO: www.lego.com

Prisco, Joanna. "Lego Goes Green with Sustainable Blocks Made from Sugarcane." *Globalcitizen.* August 8, 2018.

Shield, Charli. "The Plastic Crisis isn't Just Ugly—It's Fueling Global Warming." *Deutsche Welle English.* May 15, 2019.

Meagan Fallone, CEO, Barefoot College International

Barefoot College International: barefootcollege.org

Bangs, Molly. "A Non-Profit is Training Grandmas to Become Solar Engineers in Rural Areas Worldwide." *Vice.* September 8, 2017.

Fallone, Meagan. "Technology Is Useless If It Doesn't Address a Human Need." *Fast Company.* November 21, 2012.

Felder-Kuzu, Naoka. "Barefoot College's Evolution and the Launch of Bindi Solar, a Commercial Solar Product Line." *Microfinance News.* December 7, 2017.

Mohan, Chander. "Women Launch India's First Global Solar Products." *Krishi Jagran.* October 3, 2018.

Fatma Muzo, Tanzania Country Director, Solar Sister and Katherine Lucey, Founder/CEO, Solar Sister

Solar Sister: SolarSister.org

Chitre, Monica. "How 3 Women Are Changing the World with Solar Energy." *CleanTechnica.* April 11, 2017.

Keeling Curve Prize. "2019 Keeling Curve Prize Winners Announced." *PR Newswire.* June 28, 2019.

Solution Search and Rare. "Solar Sister, 1 Million Women Crowned as Winners of Solution Search." *Rare.* March 20, 2019.

Erica Mackie, Co-Founder/CEO, GRID Alternatives

GRID Alternatives: gridalternatives.org

Schwartz, Ariel. "Most Creative People 2015: Erica Mackie." *Fast Company.* May 11, 2015.

Sudeesa: Women-led Community Cooperatives

Sudeesa: www.Sudeesa.lk

Facts and Details. "Mangroves and the Plants and Animals That Live There." *Facts and Details.* January 2012.

Greenwood, Veronique. "To Save Coral Reefs, First Save the Mangroves." *National Geographic.* February 11, 2015.

Momentum for Change. *Sri Lanka Mangrove Conservation Project. United Nations Climate Change.* January 2018.

Perera, Amantha. "Women Lead Effort to Protect Sri Lanka's Mangroves." *Christian Science Monitor.* July 14, 2015.

Rasmussen, Carol with Mike Carlowicz. "New Satellite-Based Maps of Mangrove Heights." *NASA Global Climate Change.* February 27, 2019.

Rivers, Brendan. "Mangroves, Climate Change, and Hurricanes." *NPR: Morning Edition.* August 29, 2019.

Sri Lanka Sudeesa Seacology Mangrove Museum. *Mangrove Flowers of Sri Lanka.* (Sri Lanka: Sudeesa, 2019). https://www.sudeesa.lk/mangroves-Flowers-book.pdf

The Economist Briefing. "Climate Change is a Remorseless Threat to the World's Coasts." *The Economist.* August 17, 2019.

Natalie Isaacs, Founder/CEO, 1 Million Women

1 Million Women: www.1millionwomen.com.au

Isaacs, Natalie. *Every Woman's Guide to Saving the Planet.* (New York: Harper Collins, 2018).

Carina Millstone, Executive Director, Feedback

Feedback: feedbackglobal.org

Moskin, Julia, Brad Plumer, Rebecca Lieberman, and Eden Weingart. "Your Questions about Food and Climate Change, Answered." *New York Times*. April 30, 2019.

Sedacca, Matthew. "A Restaurant With No Leftovers." *New York Times*. January 1, 2020.

Anna Bergström, Mall Manager, ReTuna

ReTuna Återbruksgalleria: www.retuna.se/english

Savage, Maddy. "This Swedish Mall is the World's First Ever Secondhand Shopping Center." *Huffington Post*. November 28, 2018.

Shaw, Dougal. "Welcome to My High-Fashion, Trash Shopping Mall." *BBC News*. January 29, 2019.

Steere, Mike. "The Beautiful New Face of Second-hand Shopping." *CNN*. June 3, 2019.

Nina Smith, Founder/CEO, GoodWeave International

GoodWeave: goodweave.org

Jacobs, Josh and Reeva Misra. "Child Labor: The Inconvenient Truth Behind India's Growth Story." *The Washington Post*. August 21, 2017.

Kwauk, Christina and Amanda Braga. "3 Ways to Link Girls' Education Actors to Climate Action." *The Brookings Institution*. September 27, 2017.

Kwauk, Christina and Amanda Braga. "Malala Says Educating Girls Is Key to Slowing Climate Change." *Global Citizen*. April 24, 2017.

Smith, Nina. "Is Child Labor out of Fashion? Meet Arshi's Family and Find Out." *C&A Foundation*. May 15, 2019.

Jenny Ng, Executive Director, Green Monday

Green Monday: greenmonday.org

Daily Chart. "How Much Would Giving Up Meat Help the Environment?" *The Economist*. November 15, 2019.

Genung, Andrew. "It's the Year of the Pig. Is it Also the Year That Fake Pork Takes off in China?" *The Washington Post*. March 18, 2019.

Kong Wenzheng. "Millennials Changing US Restaurants." *China Daily*. August 8, 2019.

Yang, Stephanie. "American Companies are Hungry for a Cut of China's Fake-Meat Market." *Wall Street Journal*. December 5, 2019.

Melinda Kramer, Co-Funder/Co-Director, Women's Earth Alliance

Women's Earth Alliance: womensearthalliance.org

Marianne Weinreich, Chairman, and Marie Kåstrup, Vice Chair, Cycling Embassy of Denmark

Cycling Embassy of Denmark: cycling-embassy.dk

Martin, Melanie J. "How Riding a Bike Reduces Global Warming." *SFGate.* February 17, 2019.

Reid, Carlton. "Bicycling Could Help Save the Planet, Says IPCC Climate Report." *Forbes.* October 8, 2018

Clover Moore, Lord Mayor of Sydney

City of Sydney: www.cityofsydney.nsw.gov.au

Hannam, Peter. "Sydney Bids to Host Major Climate Conference for Women in 2020." *Sydney Morning Herald.* February 3, 2019.

Kathleen Rogers, President, EARTHDAY.org

EARTHDAY.org: www.earthday.org

Clancy, Heather. "How She Leads: Kathleen Rogers, Earth Day Network." *Green Biz.* April 21, 2015.

Miranda Massie, Founder/Director, Climate Museum

Climate Museum: climatemuseum.org

Flavelle, Christopher. "New York City Wants to Put a Climate Change 'Laboratory' on Governors Island." *New York Times.* October 6, 2019.

Margaret Klein Salamon, PhD, Founder/Board Chair, The Climate Mobilization

The Climate Mobilization: www.theclimatemobilization.org

Barnard, Anne. "A 'Climate Emergency' was Declared in New York City: Will That Change Anything?" *New York Times.* July 5, 2019.

Gabriela Rivera, EcoMadres Regional Field Manager and Dominique Browning, Co-Founder/Senior Director, Moms Clean Airforce

Moms Clean Air Force: momscleanairforce.org

Howard, Andrew. "EPA Plan to Ease Mercury Standards Raises Ire of Moms' Group, Activists." *Cronkite News, Arizona PBS.* March 18, 2019.

Sheila Watt-Cloutier, Environmental, Cultural, Human Rights Advocate

Watt-Cloutier, Sheila. *Human Trauma and Climate Trauma as One. TEDxYYC.* (video) September 13, 2016. www.youtube.com/watch?v=5nn-awZbMVo

Watt-Cloutier, Sheila. *Sheila Watt-Cloutier on the Inuit View of the World. TreeTV.* (video) July 30, 2015. www.youtube.com/watch?v=vH4Ve9U769k

Watt-Cloutier, Sheila. *The Right to Be Cold: One Woman's Fight to Protect the Arctic and Save the Planet from Climate Change.* (Toronto: Penguin Canada, 2016).

ADDITIONAL RESOURCES ON WOMEN, GLOBAL WARMING, AND CLIMATE CHANGE

Articles and Reports

The Economist. *The Climate Issue.* September 21 2019 edition.

Finucane, Anne and Anne Hidalgo. "Climate Change Is Everyone's Problem. Women Are Ready to Solve It." *Fortune.* September 12, 2018.

Foreign Affairs. *The Fire Next Time: How to Prevent a Climate Catastrophe."* Foreign Affairs. May/June 2020

Harrington, Samantha. "Countries with More Female Politicians Pass More Ambitious Climate Policies, Study Suggests." *Yale Climate Connections.* September 12, 2019.

National Geographic. *How We Saved the World/How We Lost the Planet. National Geographic Earth Day 50th Anniversary Issue,* April 2020.

Tricks, Henry. "What Would It Take to Decarbonise the Global Economy?" *The Economist.* November 29, 2018.

Books

Bolen, Jean Shinoda. *Like A Tree: How Trees, Women, and Tree People Can Save the Planet.* (San Francisco, CA: Conari Press, 2021).

Dalai Lama [Tenzin Gyatso], and Franz Alt. *Our Only Home: A Climate Appeal to the World.* (Munich-Salzburg: Hanover Square Press, 2020).

Dankelman, Irene, ed. *Gender and Climate Change: An Introduction.* (Washington, DC: Earthscan, 2010).

Doerr, John. *Speed & Scale: An Action Plan for Solving Our Climate Crisis Now.* (United States of America: Portfolio/Penguin, 2021).

Fox, Jordan. *The Changemaker Attitude: Why Individuals Matter in the Fight Against Climate Change.* (Potomac, Maryland: New Degree Press, 2020).

Gates, Bill. *How to Avoid a Climate Disaster: The Solutions We Have and the Breakthroughs We Need.* (New York: Alfred A. Knopf, 2021).

Goldstein-Rose, Solomon. *The 100% Solution: A Plan for Solving Climate Change.* (Brooklyn: Melville House Publishing, 2020).

Gore, Al. *An Inconvenient Truth: The Planetary Emergency of Global Warming and What We Can Do About It.* (New York: Rodale Books, 2006).

Gore, Al. *An Inconvenient Sequel: Truth to Power.* (New York: Rodale Books, 2017).

Harvey, Hal, with Robbie Orvis and Jeffrey Rissman. *Designing Climate Solutions: A Policy Guide for Low-Carbon Energy.* (Washington, DC: Island Press, 2018).

Hawley, Jenny, ed. *Why Women Will Save the Planet: A Collection of Articles for Friends of the Earth.* (London: Zed Books, 2015).

Johnson, Ayana Elizabeth, and Katharine K. Wilkinson, eds. *All We Can Save: Truth, Courage, and Solutions for the Climate Crisis.* (New York: One World, 2020).

Klein, Naomi. *On Fire: The (Burning) Case for a Green New Deal.* (New York: Simon & Schuster, 2019).

Klein, Naomi. *This Changes Everything: Capitalism vs. the Climate.* (New York: Simon & Schuster, 2014).

Kolbert, Elizabeth. *Field Notes from a Catastrophe: Man, Nature, and Climate Change.* (New York: Bloomsbury, 2015).

Kolbert, Elizabeth. *The Sixth Extinction: An Unnatural History.* (New York: Henry Holt and Company, 2014).

Kolbert, Elizabeth. *Under a White Sky: The Nature of the Future.* (New York: Crown, 2021).

McKibben, Bill. *Oil and Honey: The Education of an Unlikely Activist.* (New York: Times Books, 2013).

Nezhukumatathil, Aimee. *World of Wonders: In Praise of Fireflies, Whale Sharks, and Other Astonishments.* (Minneapolis: Milkweed Editions, 2020).

Robinson, Mary. *Climate Justice, Hope, Resilience and the Fight for a Sustainable Future.* (New York: Bloomsbury Publishing, 2018).

Schlossberg, Tatiana. *Inconspicuous Consumption: the Environmental Impact You Don't Know You Have.* (New York: Grand Central Publishing, 2019).

Sasser, Jade S. *On Infertile Ground: Population Control and Women's Rights in the Era of Climate Change.* (New York: NYU Press, 2018).

Wallace-Wells, David. *The Uninhabitable Earth: Life After Warming.* (New York: Tim Duggan Books, 2019).

Welch, Wilford H. *In Our Hands: A Handbook for Intergenerational Actions to Solve the Climate Crisis.* (Sausalito, California: Wilford H. Welch, 2017).

Newsletters

Climate Fwd: New York Times. (weekly email newsletter) www.nytimes.com/newsletters/climate-change

Websites

Climate Interactive. *EN-ROADS Climate Change Solutions Simulator.* www.climateinteractive.org/tools/en-roads/

United Nations Women Watch. *Women, Gender Equality, and Climate Change Fact Sheet.* www.un.org/womenwatch/feature/climate_change/factsheet.html

United States Energy Information Administration. *Energy and the Environment Explained.* www.eia.gov/energyexplained/energy-and-the-environment/where-greenhouse-gases-come-from.php

United States Environmental Protection Agency. *Global Greenhouse Gas Emissions.* www.epa.gov/ghgemissions/global-greenhouse-gas-emissions-data

ACKNOWLEDGEMENTS

Avery and I were fortunate to have help and support from people all over the world who helped us arrange interviews, double checked our facts, drove us long distances, and contributed ideas and introductions. Our gratitude goes to these people and many others:

Sono Aibe, Natalie Alwitt, Robert Avellan, Kiki Bauer, Jack Begbie, Florigna Bello, Manoj Bhatt, Caroline Boulom, Renee Brewster, Sarah Bucci, Stuart Butler, Robert Castaneda, Linda Clever, Craig Cohen, Elizabeth Colton, Emre Can Daglioglu, Amira Diamond, Michael Ferrari, Genessee Floressantos, Estelle Freedman, Bogdan Gherasim, Caroline Gilbert, Ryan Greenwood, Joseph Guglietti, Liz Hanna, David Hill, Kirk Hinshaw, Shea Hogarth, Barbara Hoppe, Dr. K. Kathiresan, Sumathi Kathiresan, Glen Kendall, Joanna Kerr, Catherine King, Susan Krieger, Cindie Juul-Larsen, Melinda Kramer, Stacy Krieg, Alvin Lee, Wendy Lesko, Will Luckman, Katrine Isabella Lund, Ems Magnus, Marina Mails, Neha Misra, Madison Morales, Archana Mukharji, Jenny Newell, Tina Ng, Kahea Pacheco, Karen Peterson, Elaine Petrocelli, Mathew Phillips, Daniel Power, Laurie Prendergast, Brandon Pytel, Francesca Richer, Elisabeth Sandmann, Eva Sandmann, Alex Sangster, Michelle Sangster, Scott Sangster, Miranda Schreurs, Nanveet Singh, Jonas Sondergard, Pete Souza, Liz Spander, Dr. Felix Sugirtharaj, Sasha Tanenbaum, Kasper Tamgsig, Fid Thompson, Claire Vince, Amanda Webster, Jennifer Weyburn, Lorraine Wykes, Denice Zeck, Charlotte Zeeberg.